The

THE ARTIST'S JOURNEY

Bold Strokes to Spark Creativity

Nancy Hillis, MD

THE ARTIST'S
JOURNEY PRESS

ISBN 978-0-9997504-1-4

To my mother, Ernestine Keeling Hillis, whose fierce love and belief in me guides my artist's journey.

To my father, John Gordon Hillis, who brought my mother red tulips on the day of my birth and inspired me with his love of Rembrandt paintings.

To my sister, Kim Hillis, who shared the hours of childhood with me riding our horses, Misty and Squire with our dog Oscar in tow, playing softball, and visiting Granny and Papa on their farm in Tomahawk, Arkansas as well as MawMaw and PawPaw.

To my oldest and dearest friend, a true Renaissance man with whom I've enjoyed wondrous conversations over the years, Dr. Neel Scarsdale.

To my cherished soulmate who encourages me every day on my creative journey, Dr. Bruce Sawhill, an endless source of surprising and insightful intellectual mash-ups, such as "memetic barium."

And most of all to my precious daughter, Kimberly Sofia Pedersen, the love, light, and miracle of my life.

RESOURCES FOR *THE ARTIST'S JOURNEY*

Thank you for buying my book. As a way of expressing my gratitude, I've created a series of videos and lessons to enrich your journey through *The Artist's Journey*. Before working your way through the book, please head over to
https://nancyhillis.com/book
and sign up to access these resources.

Table of Contents

ACKNOWLEDGMENTS

To my brilliant editor: Yolande McLean

To my interior layout designer: Christian Brett

To my cover designer: Olga Grlic

To my mentor: Jeanine Blackwell

To my friends: Tammy Pittenger, Marian Bach, Alan Javurek, Duane Couch, Dana Dion, Vera Tchikovani, Paulette Insall, Brent Bailey, David Goodman, Suzanne Feinberg, and Katherine Aimone

To my filmmaker and editors: Sidharta Pascual, Gwen Essegian, and Mark Ligon

To my daughter's friend: Kate Spencer

To my wonderful students

To my teachers: Adrienne Duncan, Jim Smyth, Brigitte Curt, and Steven Aimone

To my mentors in psychiatry: Irvin Yalom, MD and Randall Weingarten, MD

And reaching across the centuries in homage to Dante Alighieri

In gratitude to the work of

D.W. Winnicott

Christopher Bollas

John Bowlby

John O'Donohue

Clarissa Pinkola Estés

In memory of
My beloved grandparents: Ben and Pearl Keeling, Gordon and Emogene Hillis
My friends and mentors: Sharon Mayes, Peter Rosenbaum, MD,
 Jeff Reichenthal, MD, John Shillito, MD and Arthur Fry, Ph.D.
My daughter's friend: Coco Lazenby

Introduction

My life's dream and the work of my life is to help people believe in themselves, and especially in their creative process as artists.

The big idea of this small book is to give you a map for unleashing your creativity, plumbing the depths of your psyche, and expressing your own personal and authentic art so you can finally express *you* in your paintings.

The art of activating the canvas and bringing a painting to life with your own personal language of mark-making, expressive gestures, and brushwork is nothing short of miraculous. To create authentic and alive abstract paintings that are unique to you and your own vision is the ultimate attainment for an artist and yet, the most elusive.

One issue you'll face as an artist is that you can get stuck repeating what's worked for you before or trying to recreate what you love about other artists' work.

I think every artist goes through a cycle of feeling inspired by artists they admire and trying to create something

similar. Eventually you start feeling like you're creating copies, and it gets boring, no longer gratifying, because what you really want is to create and share work that's uniquely yours. You want to feel like a real artist whose work comes from inside you, from your own source.

So the *problem* you encounter as an artist is that you finally want to make work that comes *from you*, and the *challenge* is that you don't know how to make that shift.

This is where I come in. I'm going to guide you to dive deeply into **the inner shift that's essential for creating deep and personal art**.

I'm going to help you discover a profound secret, something foundational. It's a secret that threads through all my work, and through my courses and workshops with hundreds of artists. By the time you reach the end of this book, you'll be liberated to express your own personal marks, lexicon, and gestures, to explore and experiment and create your most alive, personal, and authentic work.

About the Author: I'm an abstract artist and Stanford-trained existential psychiatrist with a practice spanning over twenty years. I've found psychiatry to be relational, intuitive and creative. The nuances of delving into unknown territory in the psyche are similar to the experience of creating an abstract painting. Psychiatry began informing my art in the unfolding expressions of the person sitting across from me in session. As a visual person, never forgetting a face, I hold images in my mind which find their way into my art. One of my paintings came from the feelings of a client who was lonely after a breakup.

Likewise, inspiration for my work in psychiatry has been deeply influenced by art. In art you must stay open and flexible, allowing the painting to unfold. There's a conversation with the emerging marks and brush strokes and your responses to them. It's an ongoing process of inquiry and investigation. In painting, as in life, though there are problems to be solved there's also the ineffable, the mystery to be experienced.

My passions for psychiatry and art led me to combine the two and become an art psychiatrist, guiding artists to face their fears and create from the deep well of their own voice and vision.

My first exposure to art was as a young girl growing up in Arkansas, staring for hours at reproductions of Rembrandt's *Young Woman with a Broom* and *Man with a Gold Helmet* that hung in my home.

I studied from every angle the warrior sculpture in our living room. I marked up every scratchpad with red and purple crayons and colored the rocks and tree bark in our back yard. Fascinated by the variety of colors and textures of the twenty-six-foot-wide reclaimed-brick wall my father built in our den, I embellished it further with colorful scribbles.

Later, when I was twenty-six and training in radiology at Harvard's Brigham and Women's Hospital, I dreamt of creating abstract watercolors and writing poetry, but the rigors of residency didn't allow much free time to explore creative interests.

Though radiology was intellectually challenging and visually compelling, it didn't feed my inner artist. I

eventually switched to psychiatry, which felt closer to my creative interests. Hearing of my decision, John Shillito, the éminence grise of neurosurgery at the Brigham, said, "You're going from shadows to nuances."

I never looked back. After moving to the Bay Area and beginning my residency in psychiatry at Stanford I had an "aha" moment that changed the course of my life. Randall Weingarten, a friend and psychiatrist, invited me to a tea ceremony and poetry reading at the San Francisco Zen Center Green Gulch Farm. Something about that night was revelatory. I realized that I was missing art and beauty. I knew in that moment that I needed more than medicine in my life, and I was determined to begin my artist's journey.

The final day of seven years of residency training in internal medicine, radiology, and psychiatry, I announced that I would now begin my journey of studying art. Finding my teacher, Adrienne Duncan, I started learning sculpture. We worked with clay and an old Italian method of plaster casting, creating both representational and abstract sculptures. Later, we experimented with watercolor painting and collage.

Further exploring creativity, I developed the *Creativity & Consciousness* television series where I interviewed artists about their creative process. All the while, I studied and experimented in my studio and this led to gallery representation for my paintings in Santa Fe, New Mexico; Dallas, Texas; Maui, Hawaii; and Carmel, California. For the last eight years I've led experimental painting classes for medical alumni at Stanford Sierra Camp.

In 2016, I founded *The Artist's Journey* online courses. Most recently, I created **Studio Journey**, where I guide hundreds of artists from all over the world to create their deepest work by cultivating their studio practice.

About the book: Many artists find themselves creating erratically and feeling frustrated with the results. Or they start repeating themselves, doing what's worked before in their art, or worse, copying other artists' work. Because this is ultimately ungratifying, they throw their hands up in despair and avoid the studio.

My commitment to you is to be your guide, to encourage and inspire you even as you grapple with your own "dark night of the soul" as an artist, that moment of greatest self-doubt and despair when things feel meaningless, as if the bottom has fallen out on your life. St. John of the Cross, the sixteenth-century Carmelite priest and mystic, wrote about this feeling in his poem, "The Dark Night of the Soul."

> *On that glad night,*
> *in secret, for no one saw me,*
> *nor did I look at anything,*
> *with no other light or guide*
> *than the one that burned in my heart.*

Many have written of facing the *dark night*. One story of spiritual initiation, for example, is the Sumerian myth of Inanna's descent into the Underworld. Inanna, the goddess of love, visits the underworld where her twin sister resides to attend the funeral rites of her sister's husband. Wearing a turban, wig, dress, lapis lazuli necklace, beads, golden ring, and carrying with her a measuring rod, she journeys with her faithful servant, Ninshubur.

The gatekeeper of the underworld, Neti, commands her to give up her measuring rod to enter. Leaving Ninshubur behind, Inanna enters the first of seven gates. At each gate she's required to give up another piece of clothing or jewelry.

After entering the seventh gate, Inanna, naked, faces her angry sister and seven judges who glare at her and turn her into a corpse hanging on a hook. After three days and three nights Ninshubur gets worried and appeals to the god Enki, who creates two sexless figures, Gala-tura and Kur-jara, and sends them in to rescue Inanna. They revive her by sprinkling water on her body, and return her to Earth.

This story reflects the journey into the unconscious and the paradox of finding strength and transformation even as you experience powerlessness. Perhaps Inanna's nakedness symbolizes the dismantling of Inanna's "body armor" to arrive at her vulnerable self and face her own dark side mirrored in the form of her raging, persecutory twin sister. The seven judges symbolize the inner critic that one faces in the dark night.

As you grapple with your own moments of doubt and darkness as an artist, I'll help you remember that you're experiencing a necessary part of the life cycle of being a creator, and that *the possibility for the transformation of creating your deepest work lives at the edge of your struggle.*

Let's create an action plan to take you from where you are today as an artist to where you want to be. If you commit to coming along with me through the pages of this book on your artist's journey, I promise to provide you with the

knowledge and tools to create authentic, personal art. You'll finish this book with a thoughtful plan that provides you with the tools to trust yourself and create every day as an artist.

This requires commitment from you. But if you're dedicated to showing up, doing the reading, and implementing the understandings and tools in this book, the rewards will be far reaching and long lasting.

I believe we're all creators. To be an artist you must create. You can list a million reasons for putting off showing up and doing your work. All these reasons come down to one thing: resistance. And the deeper truth is, this resistance comes from fear. Fear shows up in various guises: self-doubt, inner criticism, second-guessing, overthinking, procrastinating, avoiding, being bored, resisting, repeating what's worked before, copying others, looking to others for approval, despondency, resignation, and so forth.

Creating brings up everything. It's fraught with perils. When we're being creative, we're in treacherous territory. Creativity asks us to be present, to be vulnerable, and to risk failure. The specter of humiliation and shame hovers over us when we're being truly creative. When you commit to creating, you may ask yourself: What if my work is awful? What if no one likes it? What if others think it's mediocre?

Yet, to not answer the call to create is to risk missing the most profound and wondrous moments of your life. To turn your face away is to lose the wonder, discovery, and aliveness that creating brings.

How will you feel a year from now if you put off creating your own personal art? As time slips away and you're distracted with quotidian concerns, will you hear your heart's siren song beseeching you to express yourself in your art?

The book you're about to read will guide, encourage, and inspire you to answer the call of your longing to finally create your deepest art—to express *you* in your art. Together we'll explore the terra incognita of your imagination, the untapped territory of your gestural expression. I'll guide you to trust yourself so that you can take risks and experiment in your art.

Join me now. *Now* is the time. Say *yes* to your art. Fall in love with painting again. Let's do this together.

Everything in the universe is calling you to claim your creative life. Let's begin.

Thank you for coming along with me on this journey.

 – Nancy Hillis

OVERTURE: PREPARING FOR YOUR JOURNEY

1. Preparing for Your Artist's Journey

In the middle of the road of my life
I awoke in a dark wood
And the true way
Was wholly lost
 – Dante Alighieri

These words written by 14th-century poet Dante Alighieri in *The Divine Comedy* speak across the centuries of being at a crossroads in your life.

Even before Dante, Homer wrote of the archetypal voyager Odysseus, inventor of the Trojan Horse, who journeyed far from home to fight for his people in the Trojan War. When the war was over, Odysseus thought the voyage home would be easy—that weeks of lifting glinting oars and dipping them down again into the sea would carry him swiftly home to his beloved Penelope.

But Poseidon, god of the sea, had other plans.

**Searching and Finding Your Way
As You Create *Is* The Journey**

As artists, we yearn to express our deepest feelings on the canvas. To feel alive as we explore our personal signature of gestural expression and mark-making. Giving ourselves permission to let loose, we're suddenly vulnerable, exposed, and raw. And now we're wrestling down the dark angels of self-doubt, wondering if we're up to the Herculean task of being "real artists."

Stepping into our studios to face the blank canvas is stepping into a place of "not knowing"—an experience of vulnerability. Making our first marks, perhaps we feel lost and unsure of what to do next.

And right away, with our first marks, the ever-familiar voice inside asks us: "Who do you think you are?"

You and I know this voice—it's the one that joins the real and imagined outer critics, agreeing with them, attacking you even as you try to defend yourself. It speaks using the *vocabulary of comparison* and finds you lacking. It expresses the belief that you're not good enough, that you've got to keep striving to attain some ever-receding, nebulous standard that's beyond your grasp.

This can happen especially when you've been on a roll, painting like your hair's on fire, only to be terrified that the muse will disappear and you won't be able to create like that again.

The blank canvas can bring up terror—and avoidance.

Every Artist Has Fear

I learned that the experience of fear is universal for creators

Don't despair. The good news is that you're not alone. We're in this together.

All my life I've been interested in creativity. In my television series, *Creativity and Consciousness*, I interviewed artists, musicians, dancers, composers, actors, and writers about their creative process.

It goes something like this:

You're living your life. It's familiar, it's known, and it's comfortable. But your feeling of familiarity is teetering on the edge of boredom and contempt. You have a nagging sense that something essential is missing. Your unlived dreams keep getting deferred because you think maybe the time isn't right. You'll get to it later. There's always later.

Meanwhile time's winged chariot is hurtling along.

There's a German saying: "Find joy in your life. It is later than you think." Something deep inside you knows that winter is coming. This is the part of you that yearns for something more.

You yearn to create—because *creation is connection with the immortal and the divine.*

Before long, you're called to answer your heart's desire to create. And you finally say "yes" to this invitation.

And when you step into the unknown, answer the call of creation—what will you inevitably face?

Perils.

And how will you feel as you plunge into this terra incognita?

Will you feel vulnerable and uncertain? Will you doubt that you're up to the task of facing your inner critic? Are you thinking, *everybody tells me this should feel great, so why am I feeling lost and anxious?*

Now, because you answered the call of your longing to create, you're on your artist's journey and that inevitably means facing the pitfalls that creating evokes—such as self-doubt, inner criticism, overthinking, second-guessing, procrastination, paralysis, avoidance, creative block, boredom, and resignation, and that's just for starters.

Why Would You Knowingly Place Yourself In Harm's Way?

When you decide to take a risk, it's because you know that to feel alive, you must take this journey. You're aware that *heeding the call of your heart's desire to create art means taking action in ways that are meaningful, mysterious, and essential.*

You also know that the deepest meaning is in the experiencing of creation.

Because imagining yourself on your deathbed regretting that you never allowed yourself to be fully present, to explore the reaches of who you are, would be a tragedy more intolerable than any risks you'll face on this journey.

Finding and Expressing Parts of Yourself: Vulnerability Is Essential

To create your deepest work as an artist, you're bound to encounter feelings of inadequacy. Feelings of not being good enough, intimidated, paralyzed, and wanting people to approve of you as a person and artist may emerge.

This is normal and expected. The antidote is to accept yourself just the way you are, to approach yourself with compassion. Trust that even if this painting or the next fifty paintings aren't satisfying, you'll have the courage to go ahead anyway, through the struggles and frustrations, realizing that it's not the product that matters, but the process itself.

What's important is what goes on *inside* you. Be aware of what interferes with being present while you create. When difficult, negative feelings come up, pay attention and make note of them.

Cultivate an Experimental Attitude

Imagine searching and finding your way as you create. Consider cultivating an attitude of exploration and experimentation rather than worrying about what the painting looks like or what the outcome will be.

Often, valuable and important insights don't reveal themselves easily and the painting you struggle with may turn out to be one of the most important works in your evolution as an artist—but you might not know it at the time.

In essence, you declare a holy "yes" to uncertainty and this perilous artist's journey of creating because you simply must live your life with aliveness and meaning.

And Then What Happens?

As in the great old stories, guides show up to help you. Dante Alighieri in *The Divine Comedy* had the Roman poet Virgil as his guide. Luke Skywalker had Yoda. Bilbo Baggins had Gandalf. Faust had Mephistopheles. (Well, three out of four isn't bad.)

You get the idea. We all need guides when we're moving into unknown realms.

You have mentors, teachers, fellow artists and, sometimes, even your own inner compass.

But ...

You mean there's more danger?

Yes. Inevitably there's the dark night. The moment you must face alone, because only *you* can go there, into your interior, your inner landscape, your relationship to yourself. Some things you must grapple with and face alone because what you're seeking is inner transformation.

Dante faced innumerable terrors on his spiritual journey. Finding himself lost in a dark wood—in the *selva oscura*—he set out to overcome this challenge by climbing a peak to reach the light, only to be blocked by three animals: a leopard, a lion, and a wolf—representing pleasure, pride, and greed.

And the challenge is the same for us: Only by facing the dark side of ourselves can we hope for wholeness or completion. At the moment Dante loses his way, the Roman poet Virgil arrives and offers to guide him. Dante hesitates until Virgil explains that it is Beatrice, Dante's true love and the symbol of divine love, who sent him to guide Dante.

Beatrice is the one who will ultimately guide Dante into Paradiso, but before they can ascend into the light, they must first pass through Hell. It's with this knowledge of the perilous journey required to reach Paradiso that Dante and Virgil set forth into the underworld.

At the first gate of Hell they see an inscription that reads: "Abandon all hope, ye who enter here." Passing through the gate they hear anguished screams and wailing, a portent of the horrors awaiting them. From there, they arrive at a ferry piloted by Charon that will take them across the river Acheron.

Charon first refuses Dante entry because he's a living person. But the venerable and long-dead Roman poet Virgil demands that Charon admit them both. Charon agrees, and as he ferries them across the river to the bowels of Hell, an earthquake strikes, and the terrified Dante faints.

Dante's journey begins with Virgil in the Inferno of Hell. Later, they journey through seven levels of suffering, undergoing spiritual growth in the Purgatorio. Finally, Virgil takes leave, since he's a pre-Christian pagan and can go no further than Purgatorio. Dante proceeds and finds inner strength to ascend into the Paradiso guided by Beatrice.

Similarly, in the medieval story of *Beowulf* we learn that Beowulf slayed the monster Grendel who was wreaking havoc on the kingdom of Denmark, only to find that there was even more evil to deal with than initially met the eye. The men in King Hrothgar's mead hall kept being slain in the middle of the night.

There was a lake nearby where Grendel's mother lived. Not even a stag coming out of the forest, thirsty, dared to place his hoof in that dark water.

To destroy the *mother* of all evil—Grendel's mother—Beowulf had to dive deep into the murky waters of the lake to confront her.

As an artist you must dive deep into the waters of your subconscious and wrestle down your fears and self-doubt and, in the end, only you can do this. No one can do this for you.

And so the *dark night* represents this moment in the story or in the cycle of creation where you face yourself and all your self-doubt. It's the hour of greatest danger, and yet it's also the opening to transformation of the self.

This dark night is when all hope feels lost, when you ask yourself: What was I thinking? Thoughts emerge such as, *I don't know what I'm doing. I'll never get there. I'm not good enough. This is a lost cause.*

In painting, this might be the middle of the painting, the moment when the work seems raw, unfinished, ugly, and chaotic.

One thing you learn in the process of creating is that some paintings simply don't work out. You never like them or resolve them. And that's OK. That's part of being an artist. Wheat always grows with chaff.

Life is like that. You're not going to like every painting.

Even so, this *dark night is the moment of transformation.*

For an artist, the big transformation takes place when you finally learn to trust yourself and give yourself permission to play. As you allow yourself to explore, experiment, and not know what's going to happen when you make a mark on your canvas, you'll find that this is when surprising and unpredictable images emerge.

And during the times when it seems like nothing is happening, everything is happening.

Instead of facing the River Styx as Dante did in the fifth circle of Hell, you may feel like you're on what I call the "River Stucks." You may feel stymied by your painting, not knowing where to go with it, whether to go forward or stop. This is where you may feel like throwing it out or giving up.

You ask others for feedback on your work and yet, deep down, you know that the decision of what to do or not do with your painting is ultimately up to you—because you're the artist, the composer, the author of your work. And your work reflects your voice and vision.

You realize that you're back to the dark night where you have to face yourself—and this includes making decisions about your work.

Even when you feel stuck, as if nothing is happening, there's a great deal of percolation and fermentation of your creative process under the surface.

Clarissa Pinkola Estés wrote of this sense of seemingly nothing happening when she describes the life/death/life cycle of creation in her book, *Women Who Run With the Wolves*. Estés explains how dying off is as essential as

birth in the creative process. She writes,

> Sometimes the one who is running from the Life/ Death/Life nature insists on thinking of love as a boon only. Yet love in its fullest form is a series of deaths and rebirths. We let go of one phase, one aspect of love, and enter another. Passion dies and is brought back. Pain is chased away and surfaces another time. To love means to embrace and at the same time to withstand many endings, and many beginnings— all in the same relationship.

So what's the transformation?

Quite simply, it's trusting yourself.

This is the first secret of the masters. This is the *holy grail* of creating.

I believe the most profound and essential experience for a creator is to trust yourself. This is what you must learn. This is more important than any amount of technique or theory.

Trusting yourself means accepting that some paintings simply don't work out, and that this is a necessary part of the creative process.

One challenge many artists face is the fear of creating "ugly" paintings. This begs the question: What is ugly? Historically, beauty has been associated with pleasure and value, whereas ugliness has been linked to disgust and devaluation.

Modern art has turned this concept on its head by exploring works that elicit strong reactions including

revulsion and displeasure. Mojca Küplen, a researcher in philosophical aesthetics, explores the aesthetics of ugliness in her work.

"The paradox of ugliness," writes Küplen, challenges us to understand "how we can value something we prima facie do not like."

EXERCISE
"Ugly Painting" Exercise

Let's explore this concept of ugly paintings with the exercise below.

• Take a large sheet of paper and write "Ugly" in large letters in the center of the paper and draw a circle around this word.

• Now, create a *mind map* by writing down anything that comes to mind when you think of the word "ugly." It could be a word or words, images, shapes, colors, memories, smells, sounds, behaviors. It can be anything that comes to mind.

• As something comes to mind, *write it down and circle it* and connect it to the word "ugly". You can draw, write, color or paste a picture on the paper. It's valuable to notice what repulses you.

• Now, in your art journal choose one thing from your mind map that you feel is ugly and create a study exploring it. For example, you might choose color. Let's explore a few colors and ask some questions about them to see what we discover. Let's work with red, green, blue, yellow, orange, brown, black, and white.

On your journal page, choose one of these colors or any other you desire, and ask yourself these questions:

• What feelings does this color elicit in me?

• What sensations do I experience?

• What associations do I have to this color?

• What memories or stories does this color bring up?

If you wrote that you hate pale green, ask yourself these questions and write down your observations. Now create a painting or several exploring this rejected color.

Another example: if you find graffiti ugly, ask yourself the questions above, write down your thoughts and create studies exploring graffiti.

Some paintings are going to seem "ugly" and chaotic. I believe these are extremely valuable works. In fact, these ugly ducklings are often the nascent forms of emerging work—work that's trying to be birthed but that at first appears awkward and uneasy.

Only by trusting yourself will you be willing to experiment, explore, and not know what will emerge in your work that day. To create immediate and alive work you've got to be willing to risk not liking the painting that develops. To make room for discovery and surprise, allow yourself to keep searching and finding your way as you go and showing us what excites you, what you love—and ultimately, who you are.

To fully explore and experiment as an artist—to show up and be present, embrace vulnerability, and allow yourself to grapple with uncertainty and the unknown— **you must trust yourself.**

To create work that's vibrating with immediacy and aliveness, imagine letting go and trusting yourself. The world doesn't need or want formulaic art. The world wants and needs you to express **you.**

Show us **you**—your vision, your voice, your truth. Only by trusting yourself will you create paintings that express your personal and authentic signature.

In the next chapter we'll explore *how* to trust yourself.

2. The Holy Grail of Creating

A person aspiring to wisdom knows
that the bottom line of a well-lived life
is not so much success
but the certainty we reach,
in the most private fibers of our being,
that our existence
is linked in a meaningful way
with the rest of the universe.
– Mihaly Csikszentmihalyi

There's a secret to fulfilling your destiny as an artist.

To express yourself in your art, to search for your truth, you must first master yourself—a never-ending wrestling match with the dark angels of self-doubt. It's similar to the biblical story of Jacob wrestling all night until daybreak with an angel by the Jabbok River after an exhausting journey in the desert wilderness.

For an artist, the minute you become comfortable is the minute you're no longer searching for your truth.

You could avoid this struggle and stay on the surface, settling for the low-hanging fruit of creating predictable, formulaic paintings. But in your heart you know that to create your deepest, most authentic and astonishing art, you must never give up the fight.

The one thing you must do is tell your truth.

And so what is this holy grail of creating?

It's trusting yourself.

This raises the question: How do you trust yourself? I've thought about this for years. It's a central concern in existential psychiatry too. Along with doing the deeper work of learning to value yourself (and this may take intensive therapy), it's important to cultivate self-trust.

It certainly helps you trust yourself if you grew up with secure attachment and learned from your parents' example of believing and trusting in you. That said, I believe we can learn to trust and value ourselves regardless of family history if we have enough support and encouragement to do so.

What does it mean to trust yourself?

You may be wondering exactly what trusting yourself means. You only have to reach back into the recesses of your mind, back to your early childhood, to remember. Or watch a child of three to five years old draw and paint and you'll see play and trust in action.

Why Play Is Essential to Artists

Children paint freely, boldly, and imaginatively. They're continually exploring and experimenting. They're the embodiment of being an artist.

They're not worried about what other people think. Exploring as they go, not knowing what's going to happen, they make their first mark and the magic begins.

Children paint from their bodies. They respond to the emerging image and paint what pleases them.

There's no second-guessing, overworking, or overthinking. When children paint, they don't doubt themselves. At some point, they declare the painting done. They have no problem finishing the painting.

Play is the work of childhood—and it's the work of your life as well

The great British child psychiatrist D. W. Winnicott was a virtuoso psychotherapist and brilliant theorist. He believed that play was essential to health, and that to help his clients play, whether they were children or adults, he needed to be able to play himself.

He embodied play in his unconventional approaches to therapy, employing a reciprocal game he developed called Squiggles. He and the client would begin with a squiggle drawing (basically a scribble) and, in turns, they'd add to it and images would emerge.

This informed the evolving narrative of the therapy, where previously unconscious material bubbled up as therapist and client played with the reciprocal drawing. Imagine what we could learn from studying how children create.

Making Room for Your Abandoned Self

Years ago, when I painted landscapes and figurative abstractions, my friend Sharon would call me and say, "Hey Nancy, let's go paint some ugly paintings!" I'd laugh uproariously and promptly gather up my paint, brushes, and panels, and leave my house in Silicon Valley to drive forty-five minutes through pastoral countryside to her twenty-six-acre ranch in San Gregorio.

Sharon and I met in a figure-painting class at the Pacific Art League in Palo Alto. She was forty-seven and had grandchildren—and a doctorate in sociology. I was thirty-five, single, and childless. She was from Tennessee and I'm from Arkansas. We liked and understood each other as native southern women.

She loved to cook breakfast, and so we'd sit down, eat, drink coffee, and talk about art and psychology. Her home was filled with immense, guttural and raw oil paintings, and her yard was strewn with monumental marble sculptures she had carved. I loved breaking away from my life in Silicon Valley as a full-time psychiatrist to visit and make art with Sharon.

The thing I'll never forget about Sharon is how fiercely experimental she was as an artist. She was the embodiment of radical creativity. Nothing was off limits. She didn't care if anyone liked her paintings. She simply knew she had to express herself.

Sharon taught me to believe in myself as an artist. The big lesson from Sharon was that there are no "ugly" paintings. It's all experimentation.

So I ask you, what if you were to allow yourself to experiment, explore and paint whatever is coming through *you* at any given moment?

There's freedom in letting your creations live—even the ones you deem "ugly"—and allowing them to just be, to not go in and "fix" them but rather to let them sit for a while. These experiences are important to the process of trusting yourself.

The Feast

I'm reminded of a story of a person attending a feast, approaching a table laden with the finest fruits of the land and sea.

In a house made of glass, a fire crackles in a manorial fireplace that's guarded by lion-headed andirons. Gales of laughter punctuate the lilting strains of a chamber orchestra as elegant guests dance and converse nearby. An unctuous hoverage of liveried servants scurries to and fro, making sure glasses are filled and proffering hors d'oeuvres. Wine and champagne fill the glasses to overflowing. Steaming silver platters heaped high with succulent roasts and other mouth-watering morsels round out the dreamy image.

The vision blurs through frosted windowpanes.

Outside this house where the feast is taking place there's an abandoned child with her nose pressed against the rain-streaked window, fogging a little circle of glass with her breath. She's looking in beseechingly—forlorn and yearning to be invited in.

Invite Your Orphaned Self to the Feast of Your Life

There are parts of yourself you've abandoned and dismissed. The question is whether you'll finally see these rejected parts as valuable and invite them back in because they have much to teach you.

Many people have heard of Carl Jung and his concept of the shadow, the unconscious aspect of the personality that the conscious ego doesn't identify in itself.

Perhaps less known is the work of Harry Stack Sullivan, the eminent American psychiatrist who spoke of three selves: the *good me*, the *bad me*, and the *not me*.

The *good me* is the self we share with the world. This is when we put our best foot forward in a job interview, on the first day of school, or on a date.

The *bad me* is the self we show only to those closest to us. It's the self we'd rather not reveal to the world at large. It might be a quirky habit, a tendency to be miserly, an argumentative nature. It's a fuller picture of ourselves, warts and all, that we show only in our most intimate relationships.

Finally, the *not me* is the self that we completely reject. It's anathema to how we see ourselves and thus it's unconscious and often projected onto others.

Likewise, our rejected paintings activate the *not me* self. They're unfamiliar, they appear as "other" and thus we reject them.

Allow Space for your Rejected Paintings

By giving yourself permission to make "ugly" paintings, you're acknowledging how vital these exploratory works are to your development as an artist.

"Ugly" paintings are often the nascent forms of something new emerging in your work, and sometimes they *are* the thing itself, a fully developed living expression much like Athena born from Zeus's forehead.

What we're talking about is the radical creativity that's the birthplace of art that surprises us.

I recently talked with an artist known for experimentation. She remarked that she likes to surprise herself when she paints. Her work is continually evolving and fresh. A large part of her process of discovery is her willingness to tolerate the emergence of "ugly" works.

Live with Your Raw Works

Let your new works live and breathe. Hang them on your wall and look at them, take them in over time, and see how you feel about them in a week, a month, a year.

You may be surprised how your vision evolves as you practice this way of seeing, imagining, and being with your exploratory works.

I believe this is one of the most potent and fruitful things you can do in your studio practice.

EXERCISE
Reflection Exercise: Let's Explore What Trusting Yourself Looks Like

- Trusting yourself while you create means not knowing ahead of time what you're going to create,
- allowing the brilliance of your gesture to express itself,
- responding intuitively and honestly to the mark you just made,
- finding your way as you go,
- painting what you love,
- showing us *you*,
- getting rid of what you don't like in your painting,
- giving yourself permission to make "mistakes" and allowing "ugly" paintings to emerge,
- exploring, experimenting, and playing.

Reflect on what trusting yourself looks like to you. Write your observations in your artist's journal.
In the next chapter we'll explore a second secret of the masters that will accelerate your growth as an artist and help you to develop self-trust and courage as an artist.

3. Cultivating Your Studio Practice

Beyond attaining the **Holy Grail** of trusting yourself, there's another secret to creating expressively alive, wondrous paintings that all masters know. It's time you learn it too. There are no shortcuts around this secret. No excuses. No compromises.

If you're serious about accelerating your growth and becoming a professional artist, you must do one thing:

Commit to drawing or painting most days. Do this for thirty days and discover the power of committing to your studio practice. Creating almost every day, with perhaps a day off every week for self care, is the most potent thing you can do for your development as an artist. The way you do this is by cultivating an attitude of exploration and experimentation. Experiencing your studio time as an opportunity for creating exploratory works and experimental studies helps you bypass your fear of the blank canvas and the pressure to create a masterpiece.

There's no way around the truth: You acquire facility and confidence by drawing and painting on miles of canvas.

This has to do with your brain, neurons, and myelin, and what we've learned from neuroscience about brain plasticity.

Create Many Painting *Starts*

A friend of mine is a phenomenal, prolific abstract painter. She's continually evolving her art. I asked her to tell me what her studio practice is, and this is what she said:

In the morning I create ten to twenty painting starts that are stream of consciousness and intuitive. The starts are on the studio wall or on the floor. Then I take a break and have some tea. When I come back into the studio, I walk around and look at these starts and pick one—or two or three—that I'm drawn to, and I paint into them further.

She cultivates her studio practice and continually creates fresh, immediate, and lively work that she personally loves, that's expressive of her own voice and vision, and that collectors clamor for. She stays on top of her game by continually exploring and experimenting in her studio.

She has thousands of works on paper, canvas, and panel, and this is part of the brilliance of her approach.

By creating many *starts* she's not attached to any one particular painting, and this gives her tremendous freedom to continually experiment and explore new ways of expressing herself. She avoids painting herself into creative corners by using this technique.

The beauty of creating many *starts* is that it awakens exploration, experimentation and bold risk-taking. Your body's intelligence comes through your gesture, and

you're able to make marks you wouldn't make if you were strategically trying to paint a certain way.

No painting is precious. The voice of your inner critic is less likely to get activated when there's less attachment to your work.

As you create *starts*, you begin to loosen up and unleash your own expression. You search and find your way as you create, trusting yourself, painting what you love, expressing *you*. Your own gestures, marks, and personal signature inevitably come through in your art.

This is the way of creating paintings that are expressively alive, personal, and wondrous.

EXERCISE
How to Accelerate Your Growth as an Artist

- Paint every day. There's no replacement for miles of canvas.

- Create five to twenty painting *starts* every day to unleash your creativity. This can be on sheets of paper or in your journal. Allow yourself to create spontaneous, stream-of-consciousness marks with no editing.

- Come back to your painting *starts* and choose several (perhaps three to five) of them to develop further.

In the next chapter, we'll explore your big "Why" for creating—and we'll explore your fear and how that fear can both help and hinder your work.

4. Why Your "Why" Matters

One of the most important issues for artists is the question of *why* you create.

It's easy to complicate things. Let's simplify.

As an artist, you're continually creating your art and your life. What life are you imagining? What gets in the way for you? What struggles do you grapple with as an artist?

Reflect on your biggest frustrations on your artist's journey and think about your big *Why* for creating. What drives you? What motivates you? What kind of experience or transformation do you desire?

What do you want your life to look like as a creator?

Your Big Why

Your *Why* is a powerful force in moving you past the inevitable resistance that showing up, being present, and creating in your studio brings up.

Your big Why will unleash your resourcefulness, perseverance, and motivation.

It's important to nurture your big *Why* and understand your reasons for why creating and why being an artist is important to you. This will help you stay focused and moving toward your big, juicy vision for yourself and keep you from getting sidetracked by things that aren't meaningful to you.

Notice the themes that have threaded through your life.

What have you loved since childhood?

EXERCISE
**Create a Mind Map of Your Life's
Recurring Motifs**

A mind map will help you visualize patterns and motifs in your life that affect your art.

To create a mind map, write your name or place a picture of yourself in the center of a large piece of paper. On the paper, write down images, symbols, words, colors, animals, and themes that come to mind when you think about your life.

To develop your mind map further, you might also find it helpful to contemplate these questions:

• What patterns emerge of all the things you love and have loved? Examples might be beloved animals, pets, music, musical instruments, books, stories, poems, food, nature.

• What experiences or activities stand out as significant or meaningful? Examples might be hiking, camping, swimming, skating, travel, personal stories, family vacations, trips, school experiences, cooking, dancing.

• What excites you? Examples might be art, literature, film, personal relationships, music, creating dolls, playing with children, travel.

• What do you love about your work? Do you love the materials of art? The smell of paint? The excitement of the first marks? Color? Experimentation? Line? The emotional feeling of your painting? Expressing you in your art? How you feel when you create?

• What do you struggle with in your art? Fear? Self-doubt? Inner criticism? Procrastination? Blockage? Stuck? Overthinking? Starting? The middle? What to do next?

Finishing paintings? Describe your greatest struggles as best you can.

- What do you desire for your art? Personal expression? Exploration? Play? Sales? Appreciation from your audience? Recognition? Meaning? A certain feeling?

- Why do you create art? Why is creating art important to you? What drives you? Why do you keep creating even when you're frustrated?

The Six-Maquette Story

My first love was sculpture. One of my favorite artists was the British sculptor Henry Moore. His sculptures referenced organic forms he observed on his walks in nature. He'd create *maquettes* or little studies from these organic, feminine shapes. They were essential, exploratory precursors to his monumental works.

Inspired by Henry Moore, I decided to study sculpture the day I finished seven years of post-medical school training in internal medicine at St. Mary's Hospital in San Francisco, diagnostic radiology at the Brigham and Women's Hospital in Boston, and psychiatry at Stanford.

I knew nothing about sculpture. I felt intimidated by my lack of knowledge and experience and so I decided to take private lessons rather than attend an art class. After a much research, I finally found a private sculpture teacher through my local art league.

I called her, introduced myself, and told her I wanted to study sculpture.

She told me to buy a fifty-pound bag of clay and bring it to her house.

I said: "I don't know what I'm doing."

She replied: "Wonderful!"

At that moment, I knew I'd found my teacher.

At the first lesson she asked me to pull out six clumps of clay and make six moves on each of them.

Her instructions were, "Don't think. Don't worry. Just make six moves."

I made six moves on six clumps of clay.

"Those are your moves," she declared. "No one else in the world makes those moves. Your moves will thread through all your work."

I never forgot that moment.

That moment was echoed one evening, many years later.

I was driving home after seeing psychiatry clients in Palo Alto, California when I heard an interview with the cellist Yo-Yo Ma on local radio. The conversation etched in my mind was when the interviewer asked Yo-Yo who his most important teacher was.

He answered that it was his first teacher, the one he studied with in France when he was around four years old.

When asked why his first teacher was the most important to him, Yo-Yo said it was because he felt loved by her.

This resonated deeply with me because I felt loved by my first teacher too. The one I just described in the story, Adrienne Duncan.

Now, in the spirit of my wonderful teacher, I ask you to believe in your own moves, your own marks, your own gestures in the exercise below.

EXERCISE
Create Six Maquettes

I've created a special series of videos to guide you through the exercises in *The Artist's Journey*. Before we begin, if you haven't already done so, head over to https://nancyhillis.com/book to sign up and start implementing these concepts in your studio.

For this exercise you'll need a few supplies:

• a piece of paper 11" × 14" or larger and
• a mark-making tool such as a graphite pencil, marker, crayon, or piece of charcoal. You can also use a brush and paint.

Now, draw six squares or rectangles on a piece of paper. Make six marks in each square or rectangle.

Don't think. Don't worry. You can't do this wrong. Just make six moves.

These are your marks. This is your lexicon. This is your *personal signature*. These marks will thread through all your work.

5. Painting is a Mirror

Have you noticed that your painting process is a mirror that reflects what an ordinary mirror cannot? It reveals things about you that were previously invisible. Oftentimes what you learn by looking into this reflection is that what you most need is compassion for yourself.

One of the most important things you learn as you create is that trusting yourself is an ongoing, lifelong process. Every artist I know grapples with this challenge.

At every stage of one's career as an artist, self-doubt arises in its various guises. I see this again and again in my workshops and online courses.

Painting brings up fear because our creations are meaningful to us. We deeply care and hence we feel vulnerable because what we're doing matters.

Our ego can get involved and then all kinds of struggles ensue: inner criticism, procrastination, and feeling blocked, to name a few.

We often get attached to the idea that each painting needs to be, if not a masterpiece, at least a painting that others value. *One of the biggest issues I see students struggling with is focusing on external validation at the cost of expressing their most honest, deep, true, and raw work.*

Artists can get trapped in the desire to please family, friends, colleagues, other artists, galleries, museums, and social media.

I worked with a seasoned artist recently who was in prestigious galleries and selling work consistently. She came to me because she was feeling disheartened after years of painting to please others. She was surrounded by a community of artists who also sold their work consistently, and most had a national following.

She told me that she felt like a fraud because she wasn't creating her deepest work. *She felt she was staying on the surface by consciously only creating paintings that she knew her audience would admire and accept.* Her clients had developed expectations of what her work should look like—and she was fulfilling their expectations. Indeed, she felt that her collectors expected her to paint in a certain predictable way. This was beginning to feel like a trap.

She'd imprisoned herself by being overly concerned with pleasing her audience.

In the end, she realized that she needed to please herself. She needed to paint for herself.

Missing the Moment

I watched an interview with Helen Frankenthaler about painting for yourself, where she described how she'd painted an astonishing, marvelous piece, and then took a break to get some tea.

When she came back into her studio she started to doubt the surprising work. Her analytical mind kicked in and she thought, *maybe it just needs a little green over there.*

And she painted a swath of green only to feel that she'd ruined it.

On some deep philosophical level, I'm not sure a painting is ever truly ruined, but I understand the feeling, the experience and the conviction that it is.

I tell this story to illustrate that sometimes the moment shows up as a transcendent feeling that comes like a flash of light.

And if we blink we miss it.

How many of those moments do we miss in a lifetime? How many fleeting moments do we miss because our strategic, overthinking, critical mind kicks in and is intent upon "ruining it"?

Is a Painting Ever Ruined?

Have you had a painful experience similar to Frankenthaler's of creating a painting that's fresh, immediate, and alive only to cover it over because you thought it needed something else? Then wind up ruminating and grieving because you feel that you've lost the image, lost something precious and true?

I would say to you that this painting, this expression is not lost. It's inside you. It came from you. This is part of you and it will come out again and again in various forms.

Yes, you took this painting further than you wish you had. On the other hand, you could get twenty sheets of paper and create variations on this theme, now with the awareness that you want to allow for the immediacy and honesty you expressed in the original work—the one you feel you ruined.

Your work will not disappear since nothing is truly lost. This expression of yours is still there and can't be taken away.

Ultimately, what I want you to remember is this: *trust yourself and know that you can continue exploring this expression, because it still lives inside you.*

Inner Narrative: Findings from Psychology

It turns out that our words matter. What we say to ourselves, our inner dialogue, affects and reflects our relationship to ourselves, and therefore it affects our art. Life really does imitate art and vice versa.

Somewhere along the way, we lose some of the pure playfulness of childhood. We become self-conscious and start overthinking, second-guessing, and doubting our work.

Interior stories and myths impinge upon our playfulness and cause us to have difficulty experimenting, exploring, and expressing ourselves creatively.

Recent research in psychology reveals that our interior conversations, the way we talk to ourselves and imagine our stories affects how we think and act. These inner narratives inform how we see and imagine ourselves. It also affects and inspires imaginative play.

"We tell ourselves stories in order to live," writes Joan Didion.

Solomon's Paradox

The biblical story of King Solomon is that he was known as one of the wisest men of his time. He gave people wonderful counsel and advice, yet he was unable to deal well with his own life issues. Psychologist Igor Grossman coined the term *Solomon's Paradox* to describe the phenomenon of being smarter and more incisive about other people's problems than our own.

What if we could take Solomon's Paradox and turn it around to help ourselves? By that I mean talking to ourselves as if giving guidance to another person?

We see an example of this with Malala Yousafzai, the Pakistani activist and youngest recipient of the Nobel Prize, when she described her approach to the Taliban. She asked herself, "If the Taliban comes, what would you do, Malala?" Her response: "I would reply to myself, 'Malala, just take a shoe and hit him.'"

Psychologist Ethan Kross heard Malala's words on The Daily Show and was intrigued. He knew that people often talk to themselves, but he didn't know whether the particular words they used mattered.

Kross ran a series of experiments and found that how people talk to themselves has a big effect on their success in life. His work shows that our inner talk, when reflecting upon challenging experiences such as having to stand up and give an unprepared speech, deeply affects our experience of ourself.

If we talk to ourself with the pronoun *I*, we're likely to perform poorly in stressful circumstances.

If we address ourself by our name we'll find that our potential for doing well on a host of tasks, from giving speeches to advocating for ourself suddenly soars.

It turns out that inner narratives riddled with first-person pronouns—using "I," as in: I'm scared; I don't know what I'm doing; Why am I doing this?; What if I blow it?—fuel inner criticism.

On the other hand, using second- or third-person pronouns or our own name—for example: "You've got this; You can do it; We're having a hard time here"—supports emotional resilience during an event or performance. Indeed, we're guiding and soothing ourself through difficult terrain.

Using "you" or "we" rather than "I" in our inner dialogue gives us space and some perspective. The research revealed one caveat about using "you" is not to say "You are…," because this is where you could get stuck in a loop of negativity.

Mindfulness practice teaches us that we can evoke the observer, the part of ourself that can step back and see a

situation with conscious awareness rather than being locked into harsh negativity and self-doubt.

Our inner narrative has origins in our childhood when we engaged in self-talk while we played. Laura Berk's work with children at the University of Southern Illinois reveals how inner talk fuels imaginative play. Berk has spent decades documenting how a kind and patient parent or teacher guides a child in calm, encouraging, step-by-step language that helps them master any task. The child mirrors this language in their private speech to teach themself things and help themself face challenging problems. Inwardly, they might say, "You can do this— try again."

Children exposed to impatient and frustrated adults learn patterns of self-defeating talk. They tend to get mad at themselves when feeling confused or unsure. They use derogatory self-talk such as "You're stupid," or, "You can't do anything." The child ends up giving up and not mastering the task.

The words we heard in childhood influence both our thinking brain, the cortex, and our emotional brain, the amygdala. Emotional memories exert influence over our current lives as adults. And these memories can cause us fear and inhibition. Being aware of the words we say to ourselves now, we can use inner language that begins to transform our experiences.

EXERCISE
Soften Your Inner Critic with
Your Inner Language

- Practice your inner narrative, saying "you" or "we" or your name rather than "I."

- Have a dialogue with yourself. Ask the more mature, wise, reasonable part of yourself:
Why are you nervous? What are you worried about? Imagine yourself as a wise person. What would you say to yourself if you were that wise one? Another way to work with this is to evoke the observer/witness, the part of you that can step outside yourself and speak to you as if you're another person. Imagine for a moment that your name is Marian. When you're struggling with your painting and you're saying negative things to yourself, you could say, "Marian, how else can you think about this?"

- Write to yourself in your journal. Use your name or "you" or "we" or "let's" rather than "I." Don't say "You are," which can get you stuck in a loop of negativity. Instead, say things like, Let's try. You will…You can…You've got this…You're on it…We can do this!

- Check in with yourself while you're creating and afterward. Use "you" or your name in your conversation with yourself.

Research shows that people experience less shame and display more emotional resiliency using this approach. When recalling bad experiences, using second- or third-person pronouns makes it easier to see things in perspective. You begin to imagine how little changes might make a big difference. This mindful shift distances you from the situation and helps you to see and feel what's upsetting you. You're able to focus on *why* you're upset rather than be immersed in the feeling.

Are you noticing an interior narrative that fuels your fear and causes you to doubt yourself? What are the stories and myths you're telling yourself that are stopping you from creating your deepest work? What inner predator is keeping you in line, stealing your dreams, keeping your life small?

What big, bold, juicy artistic dreams are waiting to be unleashed in you?

In the next chapter we'll explore practical ways of moving past fear in your paintings.

EMBARKING ON YOUR JOURNEY

6. The Essential Mystery of Creation

If approached in friendship, the unknown, the anonymous, the negative, and the threatening gradually yield their secret affinity with us.
As an artist, the human person is permanently active in this revelation. The imagination is the great friend of the unknown.
 – John O'Donohue

Creating brings up fear in its various guises.

Interior fear reflects your relationship to yourself. One of the questions it brings up is whether you'll create deeply or retreat and stay on the surface.

Fear arises in response to both internal and external influences. You're scared because you're anticipating negativity from the outside. Perhaps these are two facets of the same thing. Your internal fear may be modeling and hypothesizing what could happen were you to expose your work to others.

There's tension between playing it safe versus letting loose with bold strokes or unfamiliar colors. Notice feelings of uneasiness, frustration, or impatience that arise when you take risks with your painting.

Confronting your fears requires being willing to take risks and let go. If you're not throwing away some of your work, you're not evolving as an artist.

Evolution in all systems has two key parts:
1. Variation (trying new things by whatever means)
2. Selection (getting rid of the dross so the good stuff can flourish)

In the creative process variation is about experimentation. It's about searching and finding your way as you paint. It's about taking risks.

Selection is a pruning process. Much like the developing brain has millions of neuronal connections that ultimately get pruned depending upon experience and environment, selection manifests itself as flinging some paintings while keeping others. It's an ongoing refinement process.

It's important to realize that the paintings that are rejected (just like the neuronal connections that are pruned) are as vital to the creative process as the ones that are chosen.

Existential Concerns and the Fear of Disapproval

How do you feel about yourself when you don't like this particular painting you just spent the entire day and fifteen layers of paint on?

Feelings of mediocrity, of not being good enough, and of

having insufficient talent may surface. You may start to think it's too late and you're too old.

You may feel like a fraud, like you're kidding yourself about being a *real artist*.

Our concerns are existential: Does my art matter? Will I ever gain traction? Does my work have meaning, or am I deluding myself?

Our answers to questions like these interweave with interior issues of self-doubt, confusion, and disappointment.

Your fears can morph into questions: Questions of meaning, value, and identity. Survival questions. Where do I fit into the scheme of things? If I'm different, will the herd abandon me?

Here's the risk: if you paint for others, you'll continually chase approval. You'll be whipped around by the whims of your fickle audience. All it takes is one frown, one dismissive response, one negative review to crush you and stop you cold.

The challenges are these: How will you manage your fears? How will you work with them? How will you allow your fears to fuel your growth rather than cause you to stall out?

Inviting Fear Into Your Process

A powerful antidote to fear is to animate her. Imagine she's a child. Invite her into your studio much the way you invited the orphan to share the feast in Chapter 2. Create a name for her. Take her hand and invite her to join you in playing and experimenting in your studio.

The Consequences of Unmediated Fear

Remember the power of your inner narrative and talking to yourself using your own name. Imagine calling out your name and saying to yourself, "We're going to explore and experiment today in the studio. We're going to play!"

A reminder: I've created a special series of videos to guide you through the exercises in *The Artist's Journey*. Head over to https://nancyhillis.com/book to sign up and start implementing them in your studio.

Fear causes you to paint in predictable and stale ways that ultimately undermine your art because it stifles investigation and inquiry. Art is not about finding a replicable system to produce perfect paintings. It's about not knowing. Continually evolving. Seeking your truth and expressing it.

The challenge is that fear causes you to engage your strategic mind, which angles for approval and recognition from others. It's the part of your mind that thinks there's a secret code that if cracked would make you a successful artist.

The Answer Is Far Deeper

The answer is inside you, and always has been.

The most amazing work comes from a place of not knowing, from exploration and experimentation. It's raw, immediate, and unselfconscious. It's unplanned. It's an expression of your search for truth.

This is the work that surprises you. It doesn't come from thinking or strategizing. Nor does it come from laying a

Cartesian grid over your experience. It's not a formula. It doesn't come from painting today like you painted yesterday. And it doesn't come from imitating commercial success.

No, to create deeply is to enter into and allow the emergence of the unknowable.

In the next sections we'll explore how the unsaid, the unthought, and the unknown are vital to the creative process. Befriending the mystery, we explore the adjacent possible and bring visibility to the invisible. Allowing "not knowing," we fully embrace deep experimentation, which is the source of astonishing art.

Stepping Into the Mystery

Rudolf Otto, the early twentieth-century German philosopher and scholar of religion, wrote about the mysterium tremendum et fascinans. This Latin phrase reflects the idea of the mysterium as the "wholly other," entirely different from our quotidian experience.

The mysterium is a numinous, spiritual state that evokes silence and a feeling of wonder and awe. And yet it also elicits mysterium tremendum—a feeling of terror or being overwhelmed reminiscent of the Stendhal syndrome, an illness named by Italian psychiatrist Graziella Magherini based on her readings of the nineteenth-century French author Stendhal's account of an experience of the sublime that overwhelms the senses and psyche.

Dr. Magherini observed hundreds of cases of people visiting Florence who appeared to be overcome with symptoms ranging from panic attacks to psychosis lasting two or three days.

Stendhal described his experience with the phenomenon during his 1817 visit to Florence in his book *Naples and Florence: A Journey from Milan to Reggio*.

When he visited the Basilica of Santa Croce, where Michelangelo, Galileo, and Machiavelli are buried, he was overcome with emotion. He wrote:

> *I was in a sort of ecstasy, from the idea of being in Florence, close to the great men whose tombs I had seen. Absorbed in the contemplation of sublime beauty…I reached the point where one encounters celestial sensations…Everything spoke so vividly to my soul. Ah, if I could only forget. I had palpitations of the heart, what in Berlin they call "nerves." Life was drained from me. I walked with the fear of falling.*

Last, the numinous presents itself as fascinans, which is an experience of grace and mercy.

This is about stepping into the ineffable and the unknowable. It's about facing your vulnerability.

This is where the essential mystery of creation lies.
This is the magic you live for as an artist.

Unknown Known

Take bold risks. Experiment.

Allow your "ugly" paintings to emerge, because then you know for sure that you're moving into unknown territory.

You may wonder why I say this.

I painted representational landscapes for years. Twice I returned to painting landscapes, and twice I ended up losing my passion. I stopped painting for a while.
My landscapes were gems that sold well in galleries.
My collectors loved them, but there was only one problem: I was bored. I kept repeating myself, creating beautiful paintings that sold but that ultimately left me feeling unmoved.

I yearned for something else. I wanted to explore the reaches of my vision and imagination. I wanted to go into unknown territory and express what was inside me that wasn't about words or imagery or anything identifiable.

It was about my inner landscape, my internal experience that was beyond words.

As artists, we work in realms where words are mere approximations of what we're expressing, and not great ones at that.

This brings to mind for me the work of British psychoanalyst, Christopher Bollas, who wrote about preverbal awareness and the "knowing" before thought in his book *The Shadow of the Object: The Unthought Known.*

Bollas says: Early memories of being and relating find their way into language and are the reliving through language of that which is known but not yet thought.

Language is an overlay to something more fundamental, a feeling of essential aliveness sensed by your body. As an infant you arrive fully conscious and without language, experiencing the wonder of the world.

The process of rendering experience into language both adds and subtracts from this raw unprocessed signal of lived sensory input. Language makes comparisons possible but also introduces bias. It interprets and gives meaning to your life. It weaves your story into a personal tapestry.

As abstract artists we access something unknowable, that which is below our conscious threshold. We work in realms that are often beyond words and language. Perhaps some of what we express can only be articulated in a visual way, through our own visual vocabulary.

Indeed, I wanted to paint beyond visual representation and the rendering of what I knew and saw before me.

I wanted to paint big, raw, immediate, and guttural abstract paintings. I wanted to "not know" what I was going to paint. I wanted no plans. I wanted to surprise myself.

But now, I faced another big problem.

I didn't know how to paint like this.

Or at least that's what I told myself.

"I don't know how. I don't know what I'm doing. I don't know where to start."

I looked at books. I searched for classes on abstract painting but found nothing compelling.

And then I remembered a concept from mathematics and science: the idea of going from zero to one.

Zero to One: Just Begin

My partner, Bruce Sawhill, is a mathematician, physicist, and musician. Bruce taught me a concept from math that rocked my world.

He said that the difference between zero and one mathematically is bigger than the difference between any other two numbers.

I found this hard to believe. How could this be? Isn't the difference between zero and one the same as the difference between one and two?

Well, it turns out that it's not the same. I felt flummoxed by this fact.

It occurred to me that whether I ever understood the reasons for this difference or not the fact of this difference between zero and one has enormous implications for artists and creators.

The Meaning of Zero to One for Artists

The revelation I had with the concept of zero to one was the notion there's an infinity of numbers between zero and one and that going from nothing to something is an enormous feat. It's what we do every time we show up in the studio and face the blank canvas.

As artists, we face an infinity of options in the space between doing nothing (represented by 0) and doing something (represented by 1).

The hardest thing, the most miraculous thing, is to go from zero to one—to just start.

Showing Up

The most significant thing you can do for your art is to keep showing up, even when you don't feel like it. This is about going from procrastination to getting off the sofa and painting or drawing even when you feel you have nothing to express.

And it's about the enormous chasm between doing nothing and doing something. *This is zero to one.*

If you only do one thing, do this: show up consistently and do the work. Your art will grow exponentially.

In working with hundreds of artists, students, and clients over the years I've found that *the willingness to commit to your studio practice of creating, even when you're not inspired and don't feel like creating* (whether it's painting, sculpting, dancing, acting, writing, composing or any other creative art) *is the single biggest factor that will take your work to the next level.* This is how you become a pro.

In showing up consistently you're taking a stance for facing your biggest fears. Sociologist Brené Brown says she's learned that if she's not feeling absolutely terrified about her work, she's probably not showing up.

Befriending the Unknown

Blockage to the creative process is caused by fear.

Playing it safe means keeping yourself small and staying on the surface to be "acceptable." Doing this, you unwittingly rob yourself of what's inside, of the chance to go deeper.

The message is clear: being an artist is about not knowing.

It's about stepping into uncertainty, allowing mysterious and unknown aspects of yourself to bubble up from your unconscious. It's about experimenting and continually evolving the work. Allowing the "ugly" painting to emerge because you know that it represents emerging work being birthed.

A few years ago, I gave myself ten days of painting without distraction. At first, rather than exploring new territory, I found myself repeating compositions that worked. I finally got fed up creating predictable paintings and asked myself,

What If?

What if I paint in ways I don't recognize? What if I get out of the way? What if I paint like a child? What if I allow myself to not know where the painting is going? What if I just show up and respond to the painting as it emerges?

The Adjacent Possible

The theoretical biologist Stuart Kauffman describes an idea in evolutionary biology informed by his conversations with mathematician Bruce Sawhill and computer scientist Jim Herriot. It's called *the adjacent possible*.

The idea is that the act of moving forward creates the next step. Every creative move you make creates the next possibility—the adjacent possible.

I see artists in workshops and classes excited with the beginnings of their paintings. When they start a painting, they love activating the canvas with stream-of-consciousness mark-making or with intuitive gestural

expressions/shapes/color fields—only to struggle with the middle of their painting.

In particular, I see artists grappling with the issue of "ugly" paintings. An "ugly" painting is what happens when you create a painting you don't like. It's a painting that feels chaotic, frenzied, fussy, or messy. A painting you deem unfamiliar and unrecognizable.

You feel stuck. Your impulse is to cover up the marks or obliterate the painting with gesso or throw the whole thing out.

Yet this amounts to a full-scale disavowal and rejection of your newly emerging work. It's akin to disowning parts of yourself—the so-called orphaned self, which I've written about previously in this book.

Why do I say this?

I believe "ugly" paintings threaten you because they're unruly and emerge unbidden without your consent. They subvert your need for control.

They're like mutations in living things that cause unforeseeable consequences.

These paintings are unpredictable, and different from your recent work. Because you don't value them, they seem "ugly."

When you think a painting you've created is ugly, you're blinded by your current mindset of what your art is supposed to look like. And this has to do with expectations: you expect there to be some kind of logical

connection between what you created yesterday and what you create today.

And yet these expressions seem to come out of nowhere, threatening to undermine the thread of consistency in your work. You can't make sense of them. You've already envisioned a lovely painting, and this unwanted visitor is not part of that picture.

I suggest to you that your "ugly" paintings are vitally important. In fact, these paintings are probably more important by several orders of magnitude than the work you like and value.

Why do I say this? How can this possibly be?

I believe these "ugly" paintings are the nascent embryonic forms of your emerging work—primitive forms gasping for breath as they're desperately trying to be birthed.

And if you destroy them or throw them out…what's at risk?

You risk missing discovering something until now invisible in you trying to become visible.

You may end up annihilating an entire future body of work just because, in your current mindset, you can't see and therefore *won't tolerate the possibilities for the future that this "ugly" piece holds for you.*

This scenario plays out time and again, and the pattern it follows is akin to the story of the chrysalis and the butterfly.

Making the Invisible Visible

This evolutionary concept of the *adjacent possible* is analogous to what happens to you on your artist's journey.

Another way to think about the *adjacent possible* is to imagine that the act of moving forward creates a new set of next steps that would've been difficult or impossible to predict beforehand.

Like a sequence of treasure maps where each map guides you to a place where a new map is hidden. Now imagine that your act of searching not only allows you to find the next map, it *creates* it!

Just as the chrysalis is the nascent form of the butterfly, the "ugly" painting is the raw essence of new, experimental work.

It's the next step—the adjacent possible—in the evolution of your emerging body of work.

And the adjacent possible is vital to your evolution as an artist!

So if you crush the chrysalis, the butterfly never emerges. It never lives.

And so I ask you this…

Will you allow yourself to paint "ugly" paintings? Will you make room for work that's trying to be expressed but that part of you immediately and unthinkingly rejects? Will you permit the "ugly" painting to live anyway?

Will you create the space for deep experimentation, allowing unknown and unfamiliar images/shapes/marks/

gestures/colors/compositions to emerge, even though they feel uncomfortable?

And when the "ugly" painting emerges, will you value it? Will you see that "ugly" paintings come into your life bearing gifts if only you'll receive them?

Make room for both the paintings you love and the paintings that scare you—the ones you see as threatening. Make room for "ugly" paintings so you can create the deepest work of your life.

Trust yourself to explore the things that scare you. These are the unexpressed, unexplored parts of yourself where your unlived dreams reside. This is the realm of play, improvisation, and pure creativity.

This is where the magic is.

What's your experience of dealing with fear in your painting practice? Where's the juice for you? In Chapter 7 we'll explore how to get started activating the canvas with stream-of-consciousness mark-making.

EXERCISE
Ugly Painting Reflection

Reflect on your experience of "ugly" paintings.

• Have you had any "aha moments" from paintings you've rejected?

• Do you keep these paintings or throw them away? Do you paint over them?

• Have you ever hated a painting only to find yourself liking it days or months later?

• How have your "ugly" paintings affected your development as an artist?

Write down your thoughts in your art journal. Plan to revisit your observations a year from now.

7. The Cathedral of Creation

My dream and my life's work is to encourage artists to believe in themselves and in their art.

I want you to believe in *you*.

The most important concept from this entire book and from all my work is this: to explore unceasingly the most important aspect of being an artist. And I believe the most important thing you can learn is to trust yourself as you create.

It's a vulnerable thing—so the question you wrestle with is: Will you express yourself on your canvas and create meaning, or will you fall back into safe patterns and stay on the surface?

Do you start strong, activating the canvas with freedom and looseness, creating wondrous painting *starts*, and feeling intoxicated by the euphoria of creating, only to dissolve into ennui—into a kind of artistic hangover?

Do you find your inner critic stepping in second-guessing and overthinking your work?

When that happens, you may feel the urge to create paintings that are technically excellent but leave you feeling unmoved.

This brings you to a fork in the road. You can replicate your current way of working, but if you want to keep evolving as an artist, to breathe life into your paintings and create art that astonishes you, you've got to be willing to take risks, experiment and tolerate "failed" paintings.

In one scenario you play it safe. Galleries pursue you, collectors buy more of your work, and you realize you could strike a Faustian deal.

You could keep painting to please others, no matter the cost to yourself. Except, you just don't want to keep doing that.

Because ultimately you desire something more.

In this scenario you explore the reaches of your vision and imagination. You step into "not knowing" and express your deepest work.

Flow, Ikigai, and the Mysterium

This is where it happens—a meeting with the ineffable, the mysterium at the intersection of the unknown known, in the place of flow and wordless purpose as we connect to and commune with the divine vessel we inhabit.

Stepping into the place of lucid *"not knowing" is stepping into mystery*—*into* the cathedral of creation. Just as

medieval cathedrals built of mundane materials of glass and stone were designed to cultivate a psychological state of awe and rapture in us when we're in communion with the Divine, the mundane materials of art can also cultivate in us a transported state of being.

Likewise, as artists using the raw materials of pigments and mediums, we enter into a transcendent state, a state that Mihaly Csikszentmihalyi describes as flow—opening to the Divine flowing through us.

Csikszentmihalyi says that flow happens when we're involved in an activity for its own sake—a feeling of timelessness when the ego falls away. He says: "Every action, movement and thought follows inevitably from the previous one, like playing jazz."

Elsewhere he writes that, "contrary to expectation, 'flow' usually happens not during relaxing moments of leisure and entertainment, but rather when we are actively involved in a difficult enterprise, in a task that stretches our mental and physical abilities. Any activity can do it."

Csikszentmihalyi thinks that in flow states we often experience a sense of transcendence, a feeling of boundaries of the self being expanded.

Inarticulable Purpose

My friend and editor, Yolande McLean, says: "I think we all feel a powerful connection with a creative source and with inarticulable purpose. When I do my best work, it's wordless, and if there's a plan, it's a feeling, not a blueprint."

Painting Challenge: As artists, we have experiences of entering into a flow state—of stepping into a transcendent state and accessing the ineffable, timeless eternal moment.

Using the raw materials of art we access a transformed, transported state of being. This absorption is a state of mindful focus.

The Japanese concept of ikigai—literally, "iki" (to live) and "gai" (reason)—offers another way of describing how mindful focus can inform our art. We find our ikigai in a focus on craft, on small things and how small things matter. Tuning into sensory experiences, being in the here and now and releasing ourselves helps us access moments of timelessness.

Ken Mogi, author of *Awakening Your Ikigai*, says that if we can achieve flow, we'll get the most out of ikigai where it's about the moment-to-moment process. We won't feel such a need for our work or efforts to be recognized. Rather, our work becomes an end in itself—our reason for being—rather than a means to an end.

Being in flow, released at least temporarily from the burden of the self, we're immersed in a feeling of aliveness that comes from creating.

When we look at paintings we created while in a flow state, we see what bubbles up from our unconscious and see the magic that happens when we get out of the way and let go. It's time now to create art that's meaningful, alive, and expressive of the mystery that lives in each of us.

It's time to fall in love with painting again.

Lessons: In this first video you'll learn how to

- activate the canvas and create exciting painting *starts*
- start a painting from an intuitive, stream-of-consciousness gestural expression
- create rhythmic movement on your canvas
- trust yourself
- allow the brilliance of your body to express itself
- play in a way that's central to creating
- access the freedom in your body and gesture
- get started with stream-of-consciousness mark-making

The big idea is to trust yourself as you create. By searching and finding your way as you paint, you'll discover that the magic is in the "not knowing." In essence, you'll learn that *cultivating an attitude of experimentation is one of the most important and potent things you can do to develop and evolve your art.*

EXERCISE
Activating the Canvas: Trust Yourself

Painting Challenge: I encourage you to create several painting starts on paper—three to five starts. Begin with graphite marks. Allow yourself to express marks in a stream-of-consciousness fashion. Knock back some marks with an eraser if you feel like it.

When you feel satisfied with activating the surface with graphite, go in with a marker and create intuitive marks. Then, change to acrylic paint.

Allow yourself to express whatever comes through you without editing. Express your gesture and your energy. Have fun! Play! *Keep the starts you create, because you'll use them in the next chapter and video lesson on composition!*

To help you start, I recommend hopping over to my website: https://nancyhillis.com/book to register for the The Artist's Journey Resource Library where you'll find video trainings and lessons to guide you. This video is: *Activating the Canvas: Trust Yourself.*

8. Composition: Searching and Finding Your Way

You've now completed the painting challenge of activating the canvas and creating several painting *starts*.

This one studio practice of going into your studio and creating *starts* will loosen you up in wonderful ways. This practice will strengthen your work as you gain facility and confidence in your mark-making.

The next video is important for your artist's journey and creating your deepest and most meaningful work. You'll learn to trust yourself as you search and find your way, responding intuitively to the mark/gesture/shape you just made on the canvas. As you paint, listen to yourself and discover the gestures and moves your body naturally makes.

I remember struggling with composition for years, because I questioned and second-guessed every decision I made in my painting.

The problem was that, while my paintings were technically good, and they were selected for galleries and collections,

they left me cold. Quite frankly, they looked strategic and contrived to me. In brief, I became bored.

They lacked something. I didn't know what it was at the time, but it left me feeling frustrated and defeated.

One day I realized what the problem was. I was creating from "the thinker"—or strategic mind—rather than from the deeper well of my intuition.

I was wrestling down every painting as if I were Beowulf fighting for my life to overtake the monster Grendel.

And then I remembered the words of Soren Kierkegaard: *"Life is a mystery to be lived, not a problem to be solved."*

And finally I understood what he meant. In that moment I realized that the magic is in the mystery, not in the problem solving.

Everything changed the moment I realized that to create the paintings I dreamt of, paintings that were raw, immediate, decisive, astonishing, and alive, I had to do one thing:

I had to trust myself

This was not an easy thing. I was used to rendering figures and continually trying to perfect them. I had to overcome the notion that there was a formula for great art. I imagined thinking my way to better paintings. I didn't understand that the most compelling paintings come from outside of the thinking mind.

I admired Joan Mitchell's work, which reminded me of improvisational jazz. I became fascinated by the inner sources of spontaneous creation. Mitchell's work looked like pure play or lila—the Sanskrit word for divine play, the play of creation, destruction, and re-creation. The idea of lila is that creative activity represents the play of God and life is a manifestation of creative play.

I wanted to access lila. I was obsessed with the spontaneous and unfettered work of children.
I wanted to forget what I'd learned, ignore the filters, break the rules.

Little was I prepared for how difficult it would be to access play, which is a kind of homecoming to our deepest self.

But one day I got it. After circling around and struggling with this concept repeatedly, I finally knew what I had to do. I understood that it boiled down to finally trusting myself as I create.

This is what I consider the Holy Grail for creating your deepest work: Trust yourself

Trust yourself as you go further into your painting and as compositional considerations appear.
Trust that, over time, your ability to compose will become intuitive and second nature.

Composition is ultimately intuitive

Know that you can simplify composition to a few things to be aware of but not overwhelmed by.

And of course…

Don't be ruled by rules

There are many opinions about composition and you may disagree with some of mine. For instance, you may not be concerned with creating a center of interest, or you may prefer a symmetrical division of space.

In the end, you're the author, the composer, the artist. And the world wants to see you—your marks, shapes, designs, your decisions.

Lessons: In this video you'll learn how to

- bring color into the activated canvas
- trust yourself as you paint, and why it's so vital to your work
- develop your painting by creating contrasts and differences
- keep searching and finding your way as you paint
- be open to the magic of the unknown—by not planning your painting
- create layers by alternately activating the surface and veiling/covering
- solve common compositional errors quickly and easily

The big idea is that art mirrors life and your inner state. Your own life is a work in progress. You can always go back in and change things, because you're the author, the composer, the artist. *Often, a small change can make a big difference.*

There's a great deal of value in working through "mistakes." Remember what the great jazz musician Miles Davis said: *"Do not fear mistakes. There are none."*

The Paradoxical Language of Mistakes

I like to think about what I call the "paradoxical language of mistakes." This is the notion that there are both no mistakes and that mistakes are valuable and ought to be embraced, because this is often the raw material of innovation and ingenious solutions.

I think about Freud's discovery of how slips of the tongue reveal unconscious psychological material. Likewise, what can appear as a mistake in your painting may be emerging, barely conscious material trying to be expressed.

Another example of the value of mistakes in terms of innovation is the case of Post-it Notes. Spenser Silver, a chemist, was trying in 1968 to synthesize a tougher adhesive. Instead, he unwittingly created microspheres, which had a stickiness that made material removable without destroying the surface it was attached to. The question became, "What could this be used for?" Silver experienced an "aha" moment when a colleague realized that he needed to bookmark his choir hymnal without losing the scraps of paper. The rest is history. Now, the 3M Company manufactures billions of Post-it Notes every year.

As Winston Churchill wryly observed, "Most people when they stumble over the truth pick themselves up and carry on as if nothing had happened."

There's a story about quilt-makers working with cast-off fabrics, or what they called "mistakes." Women in a rural Alabama community have been making the Quilts of Gee's Bend since the 19th century. Many of these quilts were made from tattered clothes and were used to keep families warm when they had no heat in their cabins.

Gee's Bend quilts have been exhibited at the Museum of Fine Arts Houston, Indianapolis Museum of Art, Philadelphia Museum of Art, and the Whitney Museum of American Art.

Alvia Wardlaw, curator at the Museum of Fine Arts, Houston wrote of the quilts that they appear to be produced with *"a brilliant, improvisational range of approaches to composition that is more often associated with the inventiveness and power of the leading 20th-century abstract painters than it is with textile-making."*

Some of the most astonishing art and inventions come from "mistakes." Remember this as you approach your next painting.

EXERCISE
Composition: Finding Your Way

Painting Challenge: I encourage you to go back into the painting *starts* that you created in the video lesson on Activating the Canvas. Set out a limited palette of two or three colors. You might consider complementary colors. This will establish color contrast—and we know that the eye loves visual contrast.

Now, go back into your painting with the same energy and intuitive movements you had in the beginning when you created the start. Be aware of creating differences or contrasts as you go (dark vs. light, large shapes or movements vs. small, heavy vs. light lines, and so forth).

Don't overthink this. Just be aware of creating changes/ contrasts/differences intuitively as you paint. Don't worry. Enjoy and trust this process.

To help you think about composition,
I invite you to head over to my website
https://nancyhillis.com/book
to see the video: *Composition: Finding Your Way*.

9. The Dark Night of the Soul

The dark night of the soul comes just before revelation.
When everything is lost, and all
seems darkness, then comes the new life
and all that is needed.
 – Joseph Campbell

One of the biggest issues I see abstract artists grapple with is what to do when they reach the middle of the painting.

Often, artists pause at this stage and wonder, "How do I finish my painting?"

And finishing your abstract art is a whole topic unto itself. It's been said that, like a river, a painting is never finished.

Many abstract artists love the beginnings of their paintings. They love activating the canvas with intuitive, stream-of-consciousness mark-making—and the raw, guttural, alive feeling that comes from creating painting *starts*.

But then they step back and the energy shifts. They ask themselves "Now what? What do I do now?"

When you feel this, you know you're in the middle of the painting, much like Dante when he found himself feeling lost in the dark wood of the forest. Dante's challenge was to find himself through God, even though he felt wholly lost.

Or like Odysseus having won the Trojan War, setting sail for home and yet beset by ten years of innumerable struggles. The challenge Odysseus faced was to believe in himself through seemingly insurmountable odds.

As an artist, you've set up your studio, learned techniques, taken classes, created hundreds of paintings, and perhaps exhibited your works in galleries and museums. You may have studied art in college or earned an MFA.

But in the end, like the battles of Dante and Odysseus, the real battle is internal. You must master yourself to reach your destiny as an artist.

This brings us to the *dark night of the soul.*

The moment when you feel lost, not knowing what to do.

And this is when the *inner critic* shows up in full regalia with self-doubt, second-guessing, overthinking—and perhaps a desire to cover up or throw out all the work you've done.

The dark night of the soul is a crucial moment—the paradoxical moment that's rife with imagined disaster, yet pregnant with possibility—the possibility of finally trusting yourself.

This moment of not knowing must be faced within yourself again and again. No one can decide this for you because in the end, you're the author, composer, and creator of your life and art.

The Self-Sabotage of the Internal Predator

In *Women Who Run With the Wolves*, Clarissa Pinkola Estés articulated the language of the inner critic by calling it the **internal predator**. This is the part of your inner narrative that undermines your confidence and wreaks havoc with your life and your art.

Permutations of the internal predator show up in the inner landscape of most of the artists I've worked with, including in my own inner landscape.

Abstract artists do any number of things to avoid what they most need to do—to trust themselves.

I've watched artists cover up all their marks, perhaps threatened or scared by their own rawness and power.

I've seen artists sabotage their work by noodling it to death, second-guessing their every move and mark.

Other variations of the predator appear when artists engage their thinking mind and try to lay a Cartesian grid of composition/design on top of an otherwise intuitive painting—and it ends up feeling contrived and strategic.

When artists move into the painting tentatively, hesitantly, ambivalently, it shows.

The reality is that some of your paintings won't work, no matter what you do. Life is like that. You're not going to like all your paintings.

Indeed, you may deem some of your abstract works as "ugly"—perhaps because they are. But perhaps some of them aren't really ugly. In fact, maybe they're so astonishing that you can't yet value them—and so you reject them immediately.

Perhaps your "ugly" works are the nascent forms of an emerging body of work.

So what do you do with the middle of the painting?

How do you bring it in for a landing?

The secret to creating alive, personal, and wondrous paintings that astonish you is very simple and yet elusive. The secret—is trusting yourself.

Imagine yourself searching and finding your way as you move into the middle of the painting.

Envision moving into this place where you don't know what's going to happen or whether or not you'll like what you create. Believe that your gesture, your marks and your moves are valid and important expressions of you.

Know that even if you don't like what you create, you can always go back into it—or put it aside.

Trust that some paintings come easily and immediately and are durchkomponiert (German for "through composed"—meaning they're an interwoven and

inseparable whole), while others have to be wrestled to the ground—just as Beowulf wrestled the monster Grendel in his life-or-death fight.

Realize that some paintings you can redeem—and others, you can't.

Allow yourself to cultivate an experience of "not knowing."

California artist Michael Cutlip said in an interview that when he goes into his studio to paint, if he already knows what's going to happen, it's all over.

And so I say to myself and to my students, "Let yourself *not know*."

And let yourself accept the fact that you may indeed create an ugly painting.

You may create a painting you simply don't like or worse, a painting that you hate—a painting that embarrasses you.

I think one of the big fears in the middle of the painting, however, is that you'll *ruin* the painting you've come to love and accept.

You're in the middle of the painting and the territory feels treacherous.

So how do you face this fear of ruining your painting?

How does this look technically or operationally?
How do you deal with the middle of the painting?
How do you finish your abstract art?

One way this looks is to step back and see your painting *start* and feel what's there and listen to what your body wants to do next. Another way is to respond to the mark you just made.

Perhaps you consider the composition and imagine various moves you want to make to strengthen the painting.

You may be looking at edges, intervals, value patterns, visual contrast, predominance. There are many considerations.

But here's the secret: decide on something and go back into the painting with the same energy you had when you were creating the painting *start*.

Make a decisive move and get out.

Make your marks and leave it alone.

In other words, don't lick the paint. You don't want your painting to be gummed to death.

You want your painting to be alive. You want to *breathe life into it.*

Ultimately, it's your painting.

Will you paint for yourself? Will you express *you* in your work?

Stay tuned for the next chapter where we explore the big game changer: Value. If there's one technical concept that will transform your painting, this is it.

You'll find out why I say this in the next chapter.

10. The Value of Values: Create What You Love

One day, I had the most delightful experience. A UPS truck pulled up to my house and delivered a heavy package. It was addressed from Wyoming. I realized that it was a surprise from a wonderful student of mine.

It was a book called *The Women of Abstract Expressionism* by Irving Sandler. It was the catalog from an exhibit my student saw at the Chicago Museum of Art. My heart quickened as I discovered wondrously alive paintings in the book.

My favorites were there: Helen Frankenthaler, Elaine de Kooning, and Joan Mitchell as well as others: Lee Krasner, Jay DeFeo, Grace Hartigan, and Joan Brown.

These women poured their hearts and souls into their paintings. The works were raw, visceral, and immediate. They were alive and personal. Some of the paintings were voluptuous and lush, while others were dark and penetrating. For me, looking at these paintings offered a window into each artist's life.

One thing I noticed throughout the catalog was an underlying substructure to most of the paintings. I believe this structure acts as a counterpoint to the exuberant expressive energy.

One chapter that particularly captured my imagination was titled, "The Advantages of Obscurity: Women Abstract Expressionists in San Francisco." Because the art scene was nascent in San Francisco in the 1940s and 1950s, the artists were liberated to create works that were non-commercial, experimental, and utterly personal.

The Radical Freedom of Obscurity

There's a radical freedom in obscurity. In obscurity, you're free to paint for yourself rather than constantly looking over your shoulder comparing your work with others— or continually second-guessing your paintings because you fear that your audience (clients, galleries, museums, curators, critics—even you) won't approve of them.

The question is, will you grab hold of this freedom and give yourself permission to paint whatever wants to come out of you?

Will you allow yourself to not know what's going to happen when you approach the canvas? Will you let yourself be surprised? Will you remain open and vulnerable?

By now we've talked about two incredibly powerful concepts:

• Activating the canvas: Trusting yourself
• Composition: Finding your way

Indeed, we explored how the most important thing of all—the **Holy Grail** is trusting yourself as you create.

And then we explored the first technical game changer: composition—how to find your way as you create—and we also learned that composition is ultimately intuitive.

There are two concepts in painting that solve ninety percent of the technical problems and they are composition and value. Now, we're going to dive into the second technical game changer: value. I'll share with you how learning about value can transform your art.

This is one of my favorite lessons.

Simplifying value patterns creates powerful paintings that read across the room.

Lessons: In this next video you'll learn how to

- simplify value to create powerful paintings
- excite the eye by creating value contrast
- create a composition with value patterns
- vary the location, size and shape of the values
- know how the eye wants to move, but also how it wants to rest … it loves contrast
- understand that the breathing space is as important as the marks
- open up your body and gesture and move beyond thought
- evoke different emotional expressions through value

The big idea is to work with the elegant solution of simplicity and constraint. Within a constraint you have an infinity of possibilities to explore. Trust yourself enough to imagine, play, and experiment as you create. Remember how free you were as a child. Access the brilliance in your body and gesture that remembers this.

Just as in life, *values are vital to your paintings. Small steps of experimentation every day make a big impact and can lead you into delight and wonder—and into creating your deepest work.* And in the end it's about expressing *you*—your voice, your vision, your truth. This is where the magic is.

EXERCISE
Value: Create What You Love

On separate sheets of paper or in your journal, experiment with value patterns. Play with dividing the space using values. You can do this using markers or black acrylic paint.

This will create the greatest value contrast: a two-value black-and-white study. Keep creating different rhythms, locations, sizes, and shapes of movements. Allow yourself to not know where this is going. Trust yourself. Just experiment. Keep creating visual contrast.

Another option is to use larger sheets of paper and make marks using a large brush or tool. Experiment with big, gestural movements. Don't think. Trust. Experiment.

Last, choose to simplify and constrain your values. Decide upon a two-, three-, or four-value pattern to work with. You could also experiment with a predominantly dark or light painting.

To help you think about values, head over to my website: https://nancyhillis.com/book to view the video: *Value: Create What You Love.*

RETURNING HOME: THE TRANSFORMATION OF TRUSTING YOURSELF ON YOUR JOURNEY

11. The Transcendent Power of Art

I am certain of nothing
But the holiness of the heart's affections
And the Truth
Of the imagination
 – John Keats

I love these words written by John Keats.

Recently, I was talking with a writer and filmmaker and the topic of what makes for transformative art came up.

He works in high tech by day, and writes screenplays and creates experimental films by night on philosophy and life.

I asked him what he thought about art and its role in transformation. What does art do for us? What does it mean? Why is it important? He powerfully and passionately exclaimed that great art moves us—and how there's a breaking through to the other side in transcendent art.

And this made me think about the idea of reaching through the canvas—of punching through to the other side, tapping into the mystery.

Above the Tent of Stars

In his *Ode to Joy*, spectacularly set to music by Ludwig von Beethoven in his 9th Symphony, Friedrich von Schiller, the German poet, philosopher, physician, and playwright spoke of a transcendent reality *"above the tent of stars"*. Despite all its vastness, the universe is gossamer-thin.

Behind the apparent physical universe is a spiritual universe.

Perhaps this is what the Celtic tradition is talking about when it says that *just beyond the bend of this reality is another, hidden reality.*

> *Behind your image, below your words, above your*
> *thoughts, the silence of another world*
> *waits. A world lives within you. No one else*
> *can bring you news of this inner world.*
> – John O'Donohue

To be an artist is to step into this world, into the mystery, and allow what bubbles up from your unconscious to be expressed.

Embrace this state of simply *not knowing* what's going to happen when you walk into your studio to create.

As artists, we understand that the art that transports us is *art that makes us feel or experience something* that

- *moves us emotionally*,
- elicits powerful *memories*,
- makes our *pulse race*,
- makes us *think*,
- *disturbs* us,
- *excites or elates us*,

- makes us *question the status quo, or*
- makes us *feel the mystery that life is.*

Perhaps art is connected to the reptilian brain, the emotional brain, and perhaps it was the image first viewed by the evolved eye.

I believe this connection between art and emotion runs deep in our biology.

The greatest works of literature, film, dance, theater, music and art reflect our human condition since the beginning of time—all our emotions, struggles, elations, decisions, crises, dreams, predicaments…everything in our life that's meaningful to us.

And these works serve as a guide on our journeys—when we're in the darkest place, the greatest peril, the deepest despair…

We have art to guide us

To transform *your* art—to create *your* deepest work…

You've got to express what's inside **you**.

We want to see **you**—your feelings, your vision, your voice, your expression.

Transform Your Art

Every time I talk to artists about taking their art to the next level, I hear variations on these questions:

Do you think I can eventually create paintings I love?
Do you think I can express me in my art?

They tell me things like, "I'm technically good but I'm not happy with my paintings." Or, "I feel stuck like I'm just copying what I see, or what's worked before. I play it safe. I keep doing the same thing over and over."

My answer to that?

Yes, you *can* create paintings that are alive, immediate, raw, wondrous, and full of *you*!

First of all—you have the desire to create work that's authentic and personal and fresh.

That's the most important thing.

You want to *finally* create your deepest work.

You're done with copying what's worked before but has left you feeling bored.

You want to breathe life into your art.

Second—you're *ready* to go deeper in your art.

You've got the passion and the commitment to say *yes* to your deeply felt call to create.

You want to create boldly and intuitively.

You want to play, explore, and experiment.

Third—you want to express *you*.

You know this is a vulnerable thing, but you want to go ahead anyway. You want to explore the mystery that is you—your life, your expression, your dreams.

All you need is the encouragement, inspiration, and guidance to step into creating your deepest work as well as the commitment to keep showing up in your studio and exploring and experimenting.

Strengthen Your Studio Practice with Quick Gestural Studies

Want to learn a powerful way to create raw, immediate, and alive paintings? a great way to cultivate your studio practice? Here's what I do to get loosened up, open creative channels, and create painting "starts."

In this video, you'll discover…

• How to quickly loosen up and paint quick, gestural, exploratory studies without planning, overthinking, or second-guessing

• How experimentation catapults your art to new levels

• Why it's important to develop your studio practice by creating many painting *starts*

• How the concepts of simplicity and constraint guide you to creating alive and wondrous paintings

Go to https://nancyhillis.com/book to view the video: *Activate the Canvas with Simplicity and Constraint.*

12. Trust Meets Practice: Stories

The biggest issue I see in every painting course and workshop I teach is the difficulty artists have trusting themselves.

I worked with a student at a workshop who created expressive, immediate, raw, calligraphic, continuous-line, scroll-like horizontal paintings.

I watched her create amazing, alive, authentic work quickly and with confidence. Then, I turned to talk with someone momentarily only to turn back and see that she'd edited almost her entire painting.

Her astonishing marks were obliterated.

Gone.

I was stunned by how quickly this artist expressed herself through gestural expression—and just as quickly covered up what she expressed.

I observed that she then looked confused and defeated.

It was as if this pure, raw expression that leapt out of her, unmediated, was absolutely terrifying, and that it had to be placed back in the container—back in Pandora's box. The treasures of her soul—of her own true expression—were being erased before my eyes.

After seeing this pattern repeated twice, I stopped her as she backed away from her work and asked,

"How are you feeling about this?"

She looked quizzically at me and asked, "You mean, you think it's done?"

I said, "Well, you're the artist—you're the composer, the author of this work."

I continued, saying, "It's your painting. It's your expression. It's what's meaningful to you. But I want you to know that, for whatever it's worth, I'd take it right now as is. I love the rawness, honesty, and immediacy of your work."

She said, "But it only took 10 minutes!"

We explored this path of inquiry further and she told me that *she felt she should keep going because it came so quickly and easily.*

As if her facility and ease made the work invalid.

She had the idea that creating art was supposed to be harder than this—that she was supposed to suffer. She mused that perhaps she was supposed to create many layers.

My heart ached when I heard this, and I said,
"It doesn't matter if it took ten seconds, ten minutes or ten years. What matters is that it's true and it expresses *you*."

For me, this experience called to mind the work of the poet Mary Oliver and her poem "The Wild Geese." I love this poem. It's about having compassion for yourself, and the opening lines say it all:

You do not have to be good.
You do not have to walk on your knees
For a hundred miles through the desert, repenting.
You only have to let the soft animal of your body
* love what it loves.*

Trust yourself to love what you love and to express what you love—and don't cover it up. Let us see you.

The most exciting and alive paintings show us you

I know this is scary.

You feel vulnerable. You may wonder, *What do I have to say? Maybe I don't have anything to contribute. Why would someone want to see me?*

Well, we *do* want to see *you* and you'll have to take a leap of faith and believe me on this.

Paintings are a mirror—they mirror your life

Paintings mirror all the raw, messy, unresolved feelings and conflicts you have—the ambivalence, the anxiety, the indecisiveness, and the beauty as well. They mirror everything.

This brings to mind the title of Irving Stone's 1962 novel about Michelangelo. It's called *The Agony and the Ecstasy*. Doesn't that say it all?

To see clearly what's in the mirror, you've got to embrace the fear and vulnerability that creating brings up.

What does creating ask of you?

Creating asks you to answer the call of your longing to create meaning—to exclaim a resounding *"yes"* to your artist's journey.

And to *trust yourself* even as you're plunged into a terra incognita.

What life are you imagining? What are you yearning for? What struggles have you grappled with on your artist's journey? Will you trust that you can create art that expresses you and that your work is important?

I love these words written by Debbie Millman, because she's talking about believing in yourself and imagining what's possible for your art and life.

> *Do what you love, and don't stop until*
> *you get what you love.*
> *Work as hard as you can.*
> *Imagine immensities.*
> *– Debbie Millman*

Your inner landscape affects everything you do as an artist. It's the interior journey of your relationship to yourself reflected in your work. Imagine exploring the reaches of what you love. Painting is a mirror. It expresses you at this moment in time.

EXERCISE
Reflection: Your Big *Why*

One of the most important things you can do as an artist is to reflect upon your big *"Why"* (or *"Whys"*) for creating. Your *Why* is a powerful force in moving you past frustration and resistance. It's an expression of your motivation and fuels resourcefulness and perseverance.

Reflect on these questions:

• Why is creating your art important to you?
• What kind of experience or transformation do you desire?
• Do you have a word or phrase you say to yourself to encourage you to create consistently?

Animating your "Why"

• If you were to animate your *Why* as a song, what would it be called?
• What kind of dance would it be?
• Which animal would represent it?
• Is there a poem that reflects your *Why*?

What informs your art?

• What are the influences in your life that inform your art?
• What are you experimenting with?
• What do you want to explore?

It's important to nurture your inspiration so you can stay focused and move towards your big vision and avoid getting sidetracked by things that aren't meaningful to you.

My promise to you is this: if you hold onto your big *Why*, you'll experiment, explore and take risks that will allow you

to do your deepest work, and if you keep documenting your discoveries in your journal, you'll finish this book with a renewed sense of inspiration and dedication to your art.

Trusting Yourself as You Create

Consider what it means to you to trust yourself—

• Stepping into the unknown—Can you imagine cultivating "not knowing"? As an artist will you embrace uncertainty?

• Playing—Will you allow yourself to play freely as you once did as a child? Why do you think Picasso said that at fourteen he could paint like Rembrandt but that it took his whole life to paint like a child?

• Experimenting—Why is experimentation at the root of your most astonishing art? Why do you need to trust yourself in order to experiment? What examples of experimentation do you see when you visit modern art museums?

• Tolerating "ugly paintings"—Why is it vital to allow yourself to create "ugly paintings"? What do ugly paintings represent? What's at risk if you reject your "ugly paintings"?

• Expressing *you*—Will you show us *you* in your art? Will you risk feeling vulnerable by showing up and taking up surface area?

• Will you dare to trust yourself when you paint? It might mean the difference between falling back on safe, strategic patterns and creating your deepest work … creating paintings that are alive and full of *you*.

13. Abstract Art:
The Intersection of Knowing and Not Knowing

*The creation of something new is not
accomplished by the intellect but by the
play instinct acting from inner necessity.
The creative mind plays with the
objects it loves.*
– Carl Jung

An artist wrote to tell me the story of a large canvas
residing in her studio. She felt it had once been quite
good, only a bit of the painting lacking something.

She told me she went into the painting many times and
quickly lost the freshness as she moved into thinking
mode.

Trying to convince herself that nothing was lost, she
ultimately felt frustrated with the piece.

By now the painting had lived for months in her studio,
leaning all alone against the wall, turned so no one could
see it, invisible—abandoned for the time being.

But every day the painting seemed to be calling her. She said it was as if it was beseeching her, calling out, "Come and get me…do something with me!"

The river always flows—and insight happens when you reflect upon the deeper pools.

It's in the slower, translucent pools that you calm yourself enough to see the deeper reasons, the *Why* of your creations.

When you stop and listen you finally see that your painting has a life of its own, and it asks you to be in relationship with it.

Indeed, like a reflecting pool, *our paintings mirror our lives.*

Paintings Have Lives of Their Own

I was mesmerized by the imagery of the painting having a life of its own and calling out to the artist.

It brought to mind Pirandello's play, *Six Characters in Search of an Author*—a play I saw years ago in Cambridge, Massachusetts, and that had me riveted.

It's an existential play about six characters who turn to the audience and implore us all to save them from their predicament of endless repetition.

The six characters created by Pirandello claim to be as alive as any of us in the audience.

They ask us to imagine the horror of being created as a character and then being left to play out the same existence over and over.

When I think of the play, the film *Groundhog Day* comes to mind—the story of a day that gets repeated over and over into infinity until it's transformed by consciousness.

Or the idea of "eternal return," Nietzsche's renewal of the concept of eternal recurrence that first emerged in Indian philosophy and in ancient Egypt, later to be explored by both Nietzsche and Schopenhauer.

This is the idea that everything that has happened or will happen has already occurred and will continue to recur infinitely without change.

What fascinated me about Pirandello's play was the way the characters turned to us at the end and convincingly exclaimed that they were alive!

They were animated and upset by the fact that the play just stopped there.

They lamented that we got to go home and live our lives and not know what's going to happen—to live in the mystery.

But they were doomed to repeat the same lines, the same story—night after night.

There were no mysteries, no surprises, no unknowns for them to experience. Just the same story, the same lines,

the same interactions repeated in front of anonymous audiences.

They were imprisoned.

Your Painting Is Alive

I was astonished by the idea that a work of art is alive.

Years later, as an abstract artist exploring experimental and intuitive expressionistic paintings, I'm convinced that our paintings are alive.

We talk a lot about the "aliveness" of a painting and how the ones that are most alive come from a place of "not knowing"—from the mystery of life.

These paintings aren't planned out or strategic. There's no Cartesian grid laid over them.

They're not informed by Descartes' dictum: *Cogito ergo sum.* I think therefore I am.

There's a deeper *knowing* that resides in a place before and beyond thought.

Fresh and wondrous paintings come from trusting the *knowing*, the intelligence in your gestural expressions, as well as from accessing and trusting the *not knowing*, the mystery of existence.

It's at the intersection of *knowing* and *not knowing* that the magic happens.

This is the dance between the considered and the spontaneous. The most astonishing work ultimately comes from trusting yourself. Only by trusting in yourself will you truly be able to let go, experiment, and explore the reaches of your imagination.

Magical things happen when you're not thinking, not worried, not strategizing about the outcome.

It's about showing up and trusting your gesture—your expression—and not knowing what's going to happen.

It's allowing the marks, passages, and shapes you just made to affect you. These marks speak to you and you respond to them in the moment. It's a conversation.

These works are raw, immediate, and alive.

Your painting is calling you, beseeching you to allow it to live.

Will you let it live?

Will you allow your authentic expression to reveal itself without covering it up?

The Mysterium: The Gold of Existence

By daring to explore and experiment, you're tapping into a deep well of wisdom stretching back millennia. We saw in Chapter 6 how great poets, scientists, and philosophers have spoken of the mysterium. **It's the gold of existence. It's what we live for.**

I think of the words of Irish poet John Keats: *"I'm certain of nothing but the holiness of the heart's affections and the truth of the imagination."*

Will you invite the mysterious into your art?
Will you express the mystery that is *you* in your art?

The artist I described at the beginning of this chapter wrote back to tell me that our conversations have encouraged her to continue exploring and noticing how her paintings speak to her.

In the end, it's about going beyond the surface of the painting. Cultivating an attitude of curiosity and inquiry, we question, even though there are no absolute answers. We continue searching and finding our own expression. There's deep meaning in this approach that asks us to face the dark night of the soul.

CODA: YOUR JOURNEY IS THE WAY

14. Taking the Plunge

Doesn't everything die at last, and too soon?
Tell me, what is it you plan to do
with your one wild and precious life?
 – Mary Oliver, "The Summer Day"

I was taking a five-mile walk in Santa Cruz overlooking the Pacific Ocean with my partner, Bruce Sawhill. I walk not only to exercise my body but to expand my mind.

There's something about walking that opens up creative channels that would otherwise lie dormant.

We got to talking about our parallel paths of reimagining our lives and how *terrifying* it is.

I believe that one of the biggest challenges of your life is realizing that you're continually creating your life.

This idea of free will, agency, and self-authorship sounds wondrous, potent, and compelling.

But the deeper truth is that it's fraught with perils so threatening that, oftentimes, you turn your face away—and continue with the status quo.

Do you stay with the known, the safe—the well-trod path?

Or do you exclaim "yes" to your yearning to create something new?

Will you allow yourself to be plunged into unknown territory like the alchemists who searched for the lapis philosophorum, the philosopher's stone, the ancient symbol of enlightenment—the substance that could transform base metals into gold or silver? The alchemist's journey to find the philosopher's stone was called the magnum opus, the great work.

It's interesting to note that *it was the journey that was the magnum opus.*

What will your artist's journey represent? Will it be about transformation? Experimentation? Self-expression? Beauty? Legacy? Meaning? Playfulness? Radical creativity? Healing?

Do you start off on your journey, not knowing what will happen and yet feel compelled to go ahead anyway?

Or do you turn your face away once again?—torn by your desire for a feeling of potency and aliveness, yet so terrified to take the leap that you choose to retreat?

Just as I was creating my website and course to reflect the *hero's journey* we continually experience in our lifetime (hence the name *The Artist's Journey*) I was personally grappling with enormous fear.

A year ago, Bruce and I were walking along ocean bluffs above the roaring surf, dreaming of birthing this course. In spite of enjoying the adventure, I felt fearful and anxious about putting all the pieces together to create the course of my dreams.

I found myself saying aloud, "I don't know if I'll ever be able to realize this dream of mine... if I'll be able to create this course—launch it—get it out there into the world. I don't know if this will ever happen. It feels overwhelming."

And the worst fear of all: "And what if nobody wants it?"

The Recurring Theme: The Dark Night of the Soul

Right when it seemed that nothing would happen—that my dream would die and everything I'd created would lie fallow...

My guides showed up—just as the Roman poet Virgil appeared when Dante was at his lowest point.

As Dante wrote in *The Inferno*: "In the middle of the road of my life, I awoke in a dark wood... And the true way was wholly lost."

I was in my own dark wood grappling with creating *The Artist's Journey*, my first online painting course, not knowing where I was or what to do, when two guides showed up to hold my hand and illuminate the way: *Jeanine Blackwell* and *Suzanne Feinberg*.

Jeanine is an expert in online course creation. She's brilliant at shepherding creatives to craft transformative

experiences for their students. Her guidance helped me develop courses that many artists have described as life changing.

Suzanne is a friend and colleague I met in Jeanine's courses. She's an expert in all things technical. She held my hand through the Gordian knot of *ePlumbing* (another Bruce mash-up to describe getting various elements of software and hardware to talk to one another) and control-flow logic (don't ask me to explain. I still don't understand it). She spent *hours* on the phone leading me through the perils of creating and helped me release my first course out into the world.

Blazing the trail of *The Artist's Journey* was like navigating a gnarly, tangled thicket fraught with unknowns.

I felt overwhelmed, and at times I'd say to myself,

Worse than not knowing what I'm doing—I don't know what I don't know.

Does that make sense?

As we continued walking along the beach, Bruce spoke about the concept of *stretch goals.*

A stretch goal is something you want to do that's just beyond your current capability—but not too far beyond.

It feels scary and exciting.

It's daunting—like going into a chi-chi restaurant in San Francisco without sufficient funds, hoping to pay for the meal with a pearl found in the oyster you ordered.

I immediately thought of Les Vygotsky, the Russian psychologist (1896–1934) who described the "zone of proximal development," which is essentially the difference between *where you are now and where you could potentially be* in your development of some ability or skill.

The idea is that with *scaffolding—with support and guidance by someone who already has acquired the skills you're trying to learn—you can accelerate the attainment of your goal.*

Revisiting the Adjacent Possible

The previous discussion of the stretch goal brings us to another concept. A stretch goal is something you want and that you can imagine attaining. The adjacent possible, as we discussed in Chapter 6, is the set of potential realities that exist nearby, whether you want them to or not.

I find that the concept of the adjacent possible keeps showing up in my thoughts, observations and experiences of creating and guiding artists on their artist's journey.

Each step illuminates the next step, but it's difficult, if not impossible, to know what will or can emerge ahead of time.

This is similar to creating abstract paintings. **When we're creating abstract paintings, we're stepping into the unknown, searching and finding our way—into the next adjacent possibility.**

And all this brings to mind some of the concepts I learned in Medicine.

What, you may ask, does Medicine have to do with art or the adjacent possible?

Well, it turns out that there's a phenomenon of healing after surgery or after being wounded that most people don't know about. It's called "healing by secondary intention."

Healing by Secondary Intention

When a wound's edges are so far apart they can't be sutured together, it has to heal from the inside out by granulation over time. This process is called healing by secondary intention.

The process of slowly filling in the wound with granulation tissue is analogous to reaching for the stretch goal, the adjacent possible, and the zone of proximal development.

If the wound isn't too big, it can be bridged.

If the aspiration, the stretch goal, is within reach in the zone of proximal development…

If scaffolding can support and guide you in your growth…

If the adjacent possible is the next step in your evolution as an artist…

Then you'll stretch into the unknown. You'll search and find your way as you paint. You'll embody an attitude of experimentation, which is at the core of being an artist.

And what a wondrous thing that is.

In the final section, we'll explore the concept of your ongoing artist's journey as the way to your deepest work.

15. The Journey of Self-Expression

The most beautiful experience we can have is the mysterious. It is the fundamental emotion that stands at the cradle of true art and true science. Whoever does not know it and can no longer wonder, no longer marvel, is as good as dead, and his eyes are dimmed.
– Albert Einstein

We come full circle back to the question of *Why. Why do you create?* Do you want to express *you* in your art?
Do you feel most connected to yourself when you create?
Does creating get you in touch with meaning and aliveness?

EXERCISE
Dream Into Your Ideal Life:
What Do You Imagine for Yourself?

Imagine your ideal life as an artist and creator. What does it look like? What life do you desire? If you pursued everything you wanted and knew that you'd succeed in getting everything you want, what would you want? Imagine yourself waking up on a day five years from now.

• Write down everything you can think of that describes you, your day, your environment, what you're wearing, what you're eating and so forth.

• Make it detailed. Make it specific.

• Paint, draw, or collage a picture for yourself of your ideal life.

Thomas Moore writes in *Care of the Soul* about how the soul loves specifics, not generalities. The soul thrives on what he calls the *particularities* of life.

I urge you to write down the particularities of your ideal life. Don't edit. Make a list of everything you want to come true.

I believe there's potency in stating and writing out your heart's big desires. As you'll see in the next story, I've personally experienced the power of declaring what you want. I encourage you to get your artist's journal out and start writing, right now.

When I was thirteen, I told my mother I wanted to be a psychiatrist when I grew up. Years went by. I explored and went on to do other things—in theater, debate, speech, chemistry, creative writing, poetry, medical school, internal medicine, and radiology.

Finally, one day when I was twenty-eight, I decided I'd had enough of radiology and I was going to study psychiatry at Stanford. I called my mother to tell her of my decision to change paths, and she said to me, "Nancy, don't you remember that you told me you were going to be a psychiatrist in seventh grade?"

I was astonished. Only then did I remember. That long-ago declaration had gone underground only to resurface fifteen years later.

This is the power of envisioning your ideal life. There's potency in speaking out and writing down what you most desire. I believe this is what Albert Camus was talking about when he said that *we spend our entire lives getting back to those one or two images that first opened our hearts.*

What images, ideas, dreams open your heart?

Getting to Know the Unknown Parts of Yourself

Great literature is filled with stories that have much to teach us about searching and finding our way in life. In *The Odyssey*, there's a little-remembered, unheralded part of the story that tells us of *one last task* that the renowned adventurer Odysseus faces before he can return home to Ithaca.

The ghost Tiresias tells Odysseus that his final task is to appease Poseidon, whose outrage he incurred when he killed Poseidon's son Polyphemus to escape from the Cyclops.

Tiresias informs Odysseus that he must walk inland to where people have never seen the sea, carrying an oar over his shoulder until a wayfarer mistakes the oar for a winnowing fan (the tool that separates wheat from chaff). Wherever that happens, Odysseus must build a shrine to Poseidon and plant the oar as a dedication—and this means leaving his comfort zone to honor the process of reparation.

The Odyssey is a story of transformation, of leaving and returning home. It's about saying "yes" to your yearning for meaning and aliveness, saying "yes" to adventure and being immediately plunged into the unknown. Finally, it's about saying "yes" to the *dark night* and to the struggle, and continuing on your journey even when all feels lost. To create your deepest work, you must accept the struggle—and it's to master yourself. The real battle is internal and it's the work of our lives.

The Odyssey also tells of searching and finding your way, meeting and learning from guides, realizing you're not alone, encountering dark nights of the soul, facing and trusting yourself, and being transformed. And finally

returning home, full circle, back to yourself, and yet, not to your old self.

Poseidon's task for Odysseus, his punishment for killing Polyphemus and nevertheless being given safe passage on the sea, was that he had to journey into unfamiliar territory. Figuratively speaking, he used his familiar skills and tools (an oar) to take him to an unfamiliar place where he could separate wheat from chaff, symbolically winnowing meaning from experience. Perhaps this means that Odysseus had to *see himself with new eyes*.

Making the Invisible Visible

These old stories have much to teach us as creators. They tell us about *finding parts of ourselves that we didn't know existed*. This is about *getting to know the nascent, developing parts of ourselves*.

As artists we're continually encountering things we haven't realized about ourselves. Imagine giving the curiosity that lives inside you license to roam. Allowing room for the "not knowing" to have a voice.

Giving surface area to playfulness, experimentation, searching, and finding your way as you go, rather than closing off the exploration too soon with planning, strategizing, and needing to know how it all turns out.

Imagine allowing yourself to explore the unexplored parts of yourself, moving into realms that are mysterious, unknown, and surprising to you. Imagine expressing parts of yourself that remain untapped.

We shall not cease from exploration
And the end of all our exploring
Will be to arrive where we started
And know the place for the first time
Through the unknown, unremembered gate
 – T. S. Eliot

The old stories reflect the concept of arrival and return. I think of Dorothy in *The Wizard of Oz*, Odysseus in *The Odyssey*, and Dante Alighieri in *The Divine Comedy*. You're continually cycling through experiences that bring you back to yourself, each time changed, even if ever so slightly.

You're gradually evolving and, hopefully, learning to trust yourself more. You know you've lived when you return home and see yourself with new eyes.

Beyond Words

We work in realms where words fail. I think visual artists oftentimes access the unsayable, unknowable (beyond knowing)—the mystery that lies beyond words and language.

Perhaps visual artists access what can only be articulated in a visual way, using a visual vocabulary. In essence, *in our deepest work we surprise ourselves* because we access the unknown—the mystery, the undiscovered parts of ourselves.

Your Art Reflects Your Life

What paintings live inside you, crying out for you to create them—the paintings that only *you* can imagine?

What paintings expressing *you*—your unique, wild, and precious life, your feelings, your experiences, your voice, your vision—will you give to the world? What legacy will you leave? Will you create your deepest work—the work that scares you, that you stretch into—the work of your dreams?

The answer is in *you*.

The world awaits.

In gratitude,
Nancy

I'd love to support, encourage, inspire and guide you on your path.

To learn more about the courses I offer, head over to my website: www.nancyhillis.com

ABOUT THE AUTHOR

Nancy Hillis, MD lives in Santa Cruz, California. She's an abstract artist, author, existential psychiatrist, and founder of *The Artist's Journey* and *Studio Journey* courses. Nancy blogs about the inner landscape of artists at https://nancyhillis.com/book. Trained in psychiatry at Stanford and fascinated with all things creative, Nancy enjoys interviewing artists about their creative process. When not painting or teaching, Nancy loves to play her cello, hike with her partner, Bruce, or listen to her daughter Kimberly sing Puccini's *O Mio Babbino Caro*, and other operatic arias.

Made in the USA
San Bernardino,
CA